DRAWING WORKBOOKS
OBJECTS

Bruce Robertson

NORTH LIGHT BOOKS

Cincinnati, Ohio

Dedication
To Frank Wood —
unique art teacher

Acknowledgement
Many of the drawings are by students or members of
the Diagram Group. Wherever possible they have
been acknowledged in the captions. The following
are acknowledgements to libraries and museums who
own the works of famous artists.
p23 Vincent Van Gogh: National Museum, Amsterdam

Artists
Joe Bonello
Alastair Burnside
Stella Cardew
Henrietta Chapman
Rebecca Chapman
Robert Chapman
Richard Czapnik
David Gormley
Brian Hewson
Richard Hummerstone
Mark Jamil
Lee Lawrence
Paul McCauley
Kathleen Percy
Jane Robertson
Paul Robertson
Graham Rosewarne

Guy S. R. Ryman
Ivy Smith
Mik Williams
Martin Woodward

Typographer
Philip Patenall

Editors
Carole Dease
Damian Grint
Denis Kennedy

Cover illustration by
Anne Robertson

© Diagram Visual Information Ltd 1987

**First published in Great Britain in 1987
by Macdonald & Co (Publishers) Ltd
London & Sydney**

ISBN 0-89134-229-X

Published and distributed in the United States by North
Light Books, an imprint of F&W Publications, 1507 Dana
Ave., Cincinnati, OH 45207

DRAWING WORKBOOKS

THIS BOOK IS WRITTEN TO BE USED.
It is not meant to be simply read and enjoyed. Like a course in physical exercises, or any study area, YOU MUST CARRY OUT THE TASKS TO GAIN BENEFIT FROM THE INSTRUCTIONS.

1. READ THE BOOK THROUGH ONCE.
2. BEGIN AGAIN, READING TWO PAGES AT A TIME AND CARRY OUT THE TASKS SET BEFORE YOU GO ONTO THE NEXT TWO PAGES.
3. REVIEW EACH CHAPTER BY RE-EXAMINING YOUR PREVIOUS RESULTS AND CARRYING OUT THE REVIEW TASKS.
4. COLLECT ALL YOUR WORK AND STORE IT IN A PORTFOLIO, HAVING WRITTEN IN PENCIL THE DATE WHEN YOU DID THE DRAWINGS.

Do not rush the tasks. Time spent studying is an investment for which the returns are well rewarded.

LEARNING HOW TO DO THE TASKS IS NOT THE OBJECT OF THE BOOK, IT IS TO LEARN TO DRAW, BY PRACTICING THE TASKS.

WORKBOOKS ARE:
1. A program of art instruction.
2. A practical account of understanding what you see when you draw.
3. Like a language course, the success of your efforts depends upon HOW MUCH YOU PUT IN.
YOU DO THE WORK.

- Drawing is magical, it captures and holds your view of the world. Once produced, the drawing is eternal: it says 'This is how I see the world at this place in this time.' It tells of your abilities and your circumstances.
- Drawing is a self-renewing means of discovering the world, and its practice is self-instructive. You learn as you go along and you improve with practice.
- Drawing is a universal language understood by everyone. It is also a concise and economical way of expressing reality and ideas.
- Drawing is a state of consciousness. You lose yourself in the drawing as you become involved in your responses to what you see. It has a calming effect when you feel depressed, agitated, ill or dissatisfied. You are outside yourself. Everyone can learn to draw. Be patient and try hard to master the skills.

TOPIC FINDER

Alignment, 22
Arranging objects, 58-59, 60

Brushes, 46

Chalks, 44-45
Charcoal, 44
Circles, 30-31
Collecting themes, 17, 55, 64
Color, 7, 8
Composition, 59
Copying reality, 8, 9
Crayons, 44-45

Design, 51-64
Dramatic viewpoint, 61

Emotional studies, 17
Exaggerating reality, 56

Form, 6, 7, 20, 21
 of irregular solids, 34-35
 judging, 11, 12, 13
 and outline, 21
 of regular solids, 32-33
 and space, 20-23
 variety of, 16
Formalization, 62
Framing, 59

Grids, 10, 11

Ideas, 62
Imagination, 62
Information, 62
Ink, 46
Intention of a drawing, 16, 17, 62

Light, 58
 reflected, 14
 and shape, 13, 14, 15
 sources, 14

Media (see Tools)
Memory drawing, 8, 9, 18
Mixed media, 46

Objective studies, 17
Observation, 7, 10, 18
 and beyond, 62-63
Overlap, 24

Paper, 40, 41, 48, 49
Pencils 42, 43
Pens, 46
Perspective, 11, 26-29
 and circles, 30-31
 parallel, 28
Picture plane, 27
Plane surfaces, 24, 25
Plotting, 10, 11, 22, 23, 27
Proportions, judging, 18

Recession, 27, 28-29
Rubbings, 37

Scale, reducing, 27
Selection of objects, 52-53, 54-55
Shape, 12, 13
 inside, 12, 30
 interpreting, 15
 and light, 13, 14, 15
Sketch pads, 49, 55
Space, 20-23
Subjective studies, 17

Super-reality, 9
Surface patterns, 25
Surfaces for drawing on, 48-49
Symmetry, 32-33

Texture, 7, 8, 36-37
Tonal values, 47
Tone, 7, 43, 47, 56
Tools, 39-50
 dry-medium, 42-43
 marks made by, 40-41, 42-43
 wet-medium, 46-47
Tracking, 20

Vanishing point, 26, 28
Variety, 16
Viewpoint, 11, 26-29, 30-31,
 60-61

Work area, 50

Drawing OBJECTS

All great artists started with observing objects and attempting to record what they saw with accuracy. The discoveries you make about the world and your abilities to record it will be invaluable when you attempt more complex subjects, such as plants, landscapes, people, and animals.

Never abandon a drawing halfway through, whatever you may think of how the drawing is progressing; only by finishing it can you judge how far it came to meet your intentions. There is no such thing as a bad drawing, only drawings that fail to achieve your ambitions. All drawings hold some interest and are an invaluable record of your efforts.

Drawing objects is the easiest of subject areas to study when you first begin to draw. You can control the selection of objects, their surroundings and the lighting. But, most importantly, you can judge the time you have available for the study and can even return at a later date and complete or make revisions to your drawing.

Remember, when first doing a drawing of an object, that it is your personal view of the object. It is that which creates a great part of the interest for the observer. Simple objects like a chair, a glove, a toothbrush, each can be invested with life if observed and drawn with love and care.

Your drawings are not copies of nature — they are interpretations. It is what you record, and what you miss out, that makes the drawing interesting.

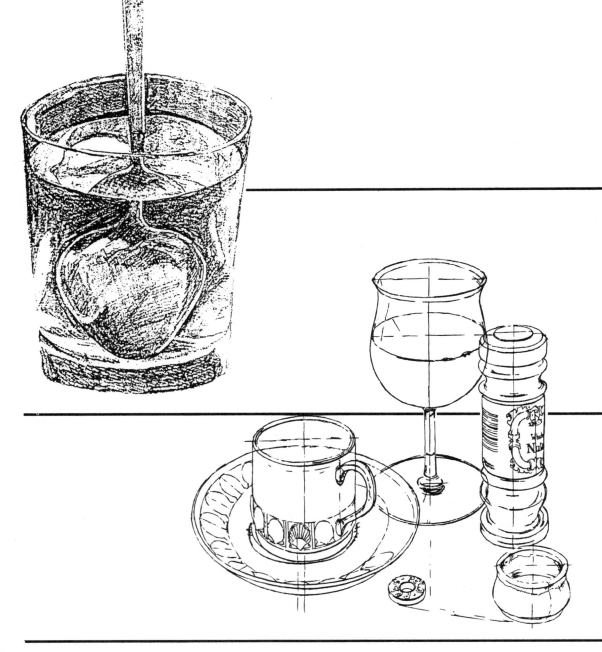

CONTENTS

Chapter One LOOKING AND SEEING

6-7	Flat or solid
8-9	Drawing is learning
10-11	Checking what you see
12-13	Outside and inside shapes
14-15	Light and shade
16-17	Diversity
18	Review

Chapter Two UNDERSTANDING WHAT YOU SEE

20-21	The space objects fill
22-23	The space they stand in
24-25	Plane surfaces
26-27	Eye level
28-29	Receding surfaces
30-31	Mastering circles
32-33	Regular solids
34-35	Irregular solids
36-37	Texture
38	Review

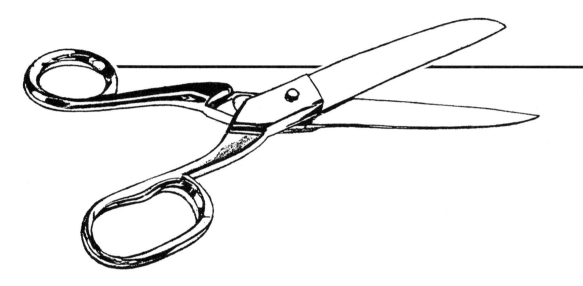

Chapter Three MASTERING TOOLS

40-41	Marks made by tools
42-43	Dry tool marks
44-45	Chalks and crayons
46-47	Wet-medium tools
48-49	Drawing surfaces
50	Review

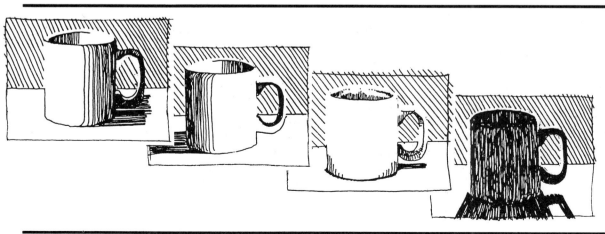

Chapter Four CONSIDERING DESIGN

52-53	Selecting objects
54-55	Drawing the unfamiliar
56-57	Adding reality
58-59	Arranging objects
60-61	Your view of objects
62-63	Beyond observation
64	Review

CHECKING YOUR PROGRESS

You may not do all the tasks in the order they appear in the book. Some require you to research sources of photographs or other artists' works, some direct you to museums and art galleries, and some may be done quickly while others can only be completed when you can devote more time to their study.

To help you keep a record of your completed Tasks, fill in the date against each numbered Task in the space given beside it.

TASK 1	TASK 31	TASK 61	TASK 91	TASK 121
TASK 2	TASK 32	TASK 62	TASK 92	TASK 122
TASK 3	TASK 33	TASK 63	TASK 93	TASK 123
TASK 4	TASK 34	TASK 64	TASK 94	TASK 124
TASK 5	TASK 35	TASK 65	TASK 95	TASK 125
TASK 6	TASK 36	TASK 66	TASK 96	TASK 126
TASK 7	TASK 37	TASK 67	TASK 97	TASK 127
TASK 8	TASK 38	TASK 68	TASK 98	
TASK 9	TASK 39	TASK 69	TASK 99	
TASK 10	TASK 40	TASK 70	TASK 100	
TASK 11	TASK 41	TASK 71	TASK 101	
TASK 12	TASK 42	TASK 72	TASK 102	
TASK 13	TASK 43	TASK 73	TASK 103	
TASK 14	TASK 44	TASK 74	TASK 104	
TASK 15	TASK 45	TASK 75	TASK 105	
TASK 16	TASK 46	TASK 76	TASK 106	
TASK 17	TASK 47	TASK 77	TASK 107	
TASK 18	TASK 48	TASK 78	TASK 108	
TASK 19	TASK 49	TASK 79	TASK 109	
TASK 20	TASK 50	TASK 80	TASK 110	
TASK 21	TASK 51	TASK 81	TASK 111	
TASK 22	TASK 52	TASK 82	TASK 112	
TASK 23	TASK 53	TASK 83	TASK 113	
TASK 24	TASK 54	TASK 84	TASK 114	
TASK 25	TASK 55	TASK 85	TASK 115	
TASK 26	TASK 56	TASK 86	TASK 116	
TASK 27	TASK 57	TASK 87	TASK 117	
TASK 28	TASK 58	TASK 88	TASK 118	
TASK 29	TASK 59	TASK 89	TASK 119	
TASK 30	TASK 60	TASK 90	TASK 120	

LOOKING AND SEEING

How do we see the world? Do your drawings reveal to you what you see when you examine an object? The first chapter directs your attention to the two main questions of your studies: what is this object really like and how do I record what I see accurately?

Drawing objects helps you develop your ability to see the world more clearly. Each small object has its own unique character, and objects with which you have lived for some time can yield up new and interesting results. Try to see the object with a fresh eye. Do not take any object's appearance at face value, look for something special about it. Try to reach into it with your mind's eye and extract more from the object than just its first appearance.

Twenty-eight Tasks will help you judge more accurately what you see. Good drawing is 90 percent good observation. Look carefully, record accurately and interpret what you see intelligently.

- The first two pages, 6 and 7, contain the most important idea in the book. Namely, how do you capture the three-dimensional world onto a two-dimensional surface?
- The next two pages, 8 and 9, direct your attention to the outstanding characteristics of each object – its unique features.

- Six pages, 10 to 15, deal with how we can portray the observable world more accurately. Firstly, by looking at the positions of objects in space, one to another. Secondly, by looking at the shapes made by space. Thirdly, by the effects of light and shade on an object.
- Pages 16 and 17 illustrate with examples how your drawing is the result of three main influences: the object's special features; its context; your response to it – how you see it. Remember that no two people see the world the same way, and ten people drawing the same subject would produce ten different views of the subject.
- Finally, page 18 offers you a challenge to test your accuracy.

6 Flat or solid

Drawing reality is the process of converting solid objects to the flat surface of the drawing paper. Drawing is not copying reality, it is interpreting it. Objects have form – their solid qualities; they have texture – their surface qualities; they have color – their pigmentation of surface; and they have shades of light and dark. The first three properties are unchangable when studying an object, the last is the result of light falling on the subject. This feature may be varied both with the type and source of light and with the reflective qualities of the surrounding objects and surfaces. Because most objects we draw are familiar to us, we understand their actual qualities fairly easily from even quite simple drawn statements. It is only when we draw unfamiliar objects or objects from an unfamiliar view-point that we must pay careful attention to explain whether the object protrudes from or recedes into the flat surface of the page.

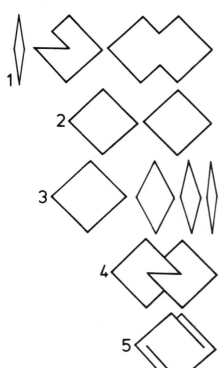

Lines
Left, we use lines to divide up areas to give the appearance of surfaces on an object. How we interpret these shapes depends partly on what we expect the object to look like from the position from which we view it.
1. The first three shapes are flat, parallel to the surface on to which they are drawn.
2. The second two are identical squares each standing on one of its corners and positioned side by side, parallel to the picture.
3. The next row is a group of four squares each one turned slightly more away from the position from which we view it.
4. The fourth row has two squares locked into one another like two clasping hands, both are turned at an angle to one another and at an angle to the surface of the page on to which they are drawn.
5. Finally one twisted surface, parts of which bend away from us and other parts of which bend toward us.

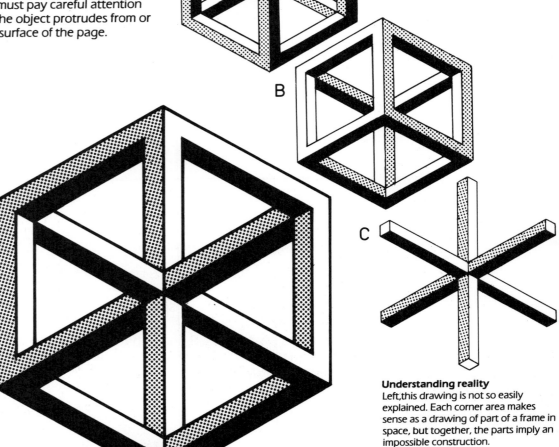

Impossible objects
Left and below, these simple drawings of a frame of square-sectioned limbs which can be turned from an open sided box seen from above (**A**). The same box (**B**) seen from below, or the interaction of a group of bars meeting in the center (**C**).

Understanding reality
Left, this drawing is not so easily explained. Each corner area makes sense as a drawing of part of a frame in space, but together, the parts imply an impossible construction.

Four Tasks
Four Tasks for you to explore the qualities of reality. Do each Task on a sheet of paper approximately 10 in (25cm) square using any drawing instrument that you feel comfortable with.

TASK 1
Form
Draw two objects of completely different forms, side by side on a table: a potato and a beer can; scissors and string; coins and leaves.

TASK 2
Tone
Draw an object with a single light source, then move the light to a new position and redraw.

TASK 3
Color
Draw two objects of different colors. Some grapes and a lemon, orange juice in a glass alongside tea in a mug, tomatoes and an egg.

TASK 4
Texture
Draw any two objects of differing texture. A wooly glove and a knife, a bowl and breakfast cereal, soap and a facecloth.

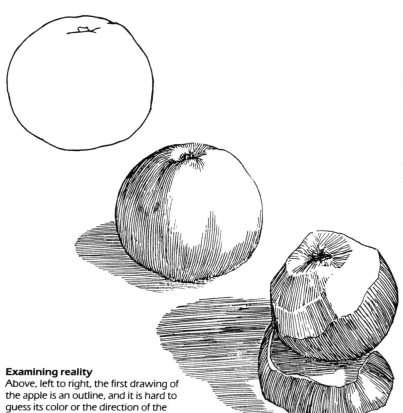

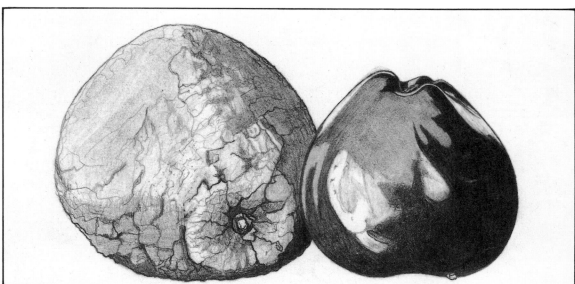

Examining reality
Above, left to right, the first drawing of the apple is an outline, and it is hard to guess its color or the direction of the light. The second drawing more clearly describes the volume of the apple – its roundness. By peeling the apple, flat surfaces can be more easily drawn. The next drawing shows a solid object because the cutaway section helps us to interpret the object as being carved out of space.

Four ways
Above, this drawing by Lee, aged 17, shows the four main features of reality: the form, texture, tone and color.

©DIAGRAM

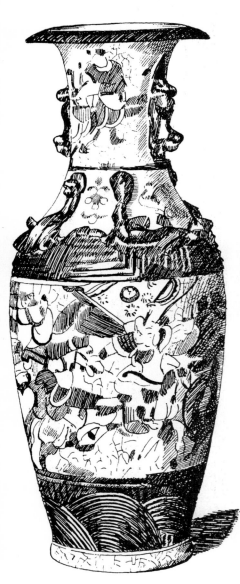

Whenever you do a drawing you improve your skill and commit the subject to memory. Whether you draw from observation, from photographs or from other artists' work. Each drawing is inscribed in your memory for later use. We all learn more about the physical world by examining it carefully and recording our impressions.

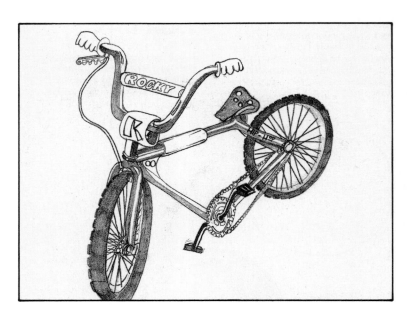

TASK 5
Capturing surfaces
Draw an object with at least two different features.
For example:
1. Colored surfaces: draw a hanging dress or patterned garment and try, in black and white, to describe the colors.
2. Textured surfaces: draw a toothbrush and try to distinguish between the smooth plastic handle and the bristles of the brush.

Remembering reality
Top right, a drawing by Mark, aged 16 years, of his bike. Although the drawing lacks a correct sense of construction, the remembered details of individual parts are very well described. Drawings from memory without the opportunity to cheat and peep at the real object are an excellent test of a retentive memory. Such drawings are more likely to be successful with objects you see very frequently, rather than objects only rarely seen. When you try Task 7, you will see how this is demonstrated.

Object drawing
Left, a pen drawing of a vase in which the artist has indicated form, color, texture and lighting.

TASK 6
Interpreting subjects
Copy this drawing using colored pencils to capture the qualities of the subject. You could also copy a colored photograph of objects using black and white pencil marks to describe the colors.

Copied reality
Right, the same student copied a similar bike from a mail order catalog. Having an interest in the subject matter of the objects you choose to draw from memory is often an additional help in remembering their details.

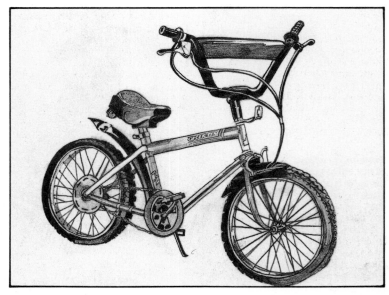

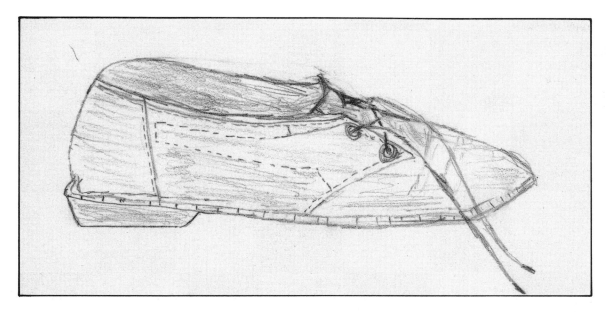

Observed reality
Granny's shoes are a wonderful study by a lady aged 75. Her shoes are very familiar objects, but when confronted with a problem of drawing for the first time, she has looked at the details with a fresh eye. We must all constantly practice drawing the objects around us so that they become committed to our memories.

Super-reality
Right, two drawings that do not record observed reality. They are very efficient descriptions of the surface qualities of the objects. This type of drawing is usually made from photographs and is used to describe the new, unused quality of an object.

©DIAGRAM

TASK 7
Memory studies
Draw from memory a small object from your kitchen, bedroom or bathroom. Try to do the drawing actual size. Leave half the page area free to add another drawing. Now fetch the object to your drawing area and carefully draw it alongside your memory attempt. Notice the differences between the two drawings. Familiar objects are easier to remember. To test this, do a detailed drawing of some object you may have seen only very briefly. For example, a Roman sandal, seen in movies, a play or reconstruction paintings. Can you do any of the following objects:
A. Red Indian feather headdress
B. Medieval crossbow
C. 1910 telephone

TASK 8
Object study
Draw one of your shoes, taking care you record every small detail of that shoe's unique qualities. Then draw a shoe from an illustration in a mail-order catalog or from a magazine. Notice the difference between the real world (your shoe) and the idealized world (magazine photograph).

Memory objects
Below, dozens of objects drawn from memory by Jane, aged 12 years. None is of objects in particular, all are generalizations of objects. In the sketch are a lamp, scissors, ruler, watches, etc.

Checking what you see

Beginners often have little confidence in their own ability to record accurately what they see. They struggle over making the objects 'look right.' The simplest way to achieve this is to relate the positions of objects to a regular pattern of straight lines. Try to imagine the object's 'footprint' on a surface — the shape it would cover if seen from directly above.

TASK 9
Objects in space

1. Select a group of thin objects such as a book, pen, ticket, clips, ruler or envelope.

2. Place these on a checkerboard or a grid you have drawn containing sixty-four squares.

3. Place tracing paper over the large grid on this page and copy on to it the exact shapes each object makes on the surface.

4. This pattern of outlines creates the 'footprint' of the objects.

TASK 10
Plotting space 1

Sit on a chair looking at the objects you set up in Task 9 with the front edge of your grid or checkerboard parallel to your sketch pad. You can change your view of the group by moving closer or further away, or by raising or lowering the plan on which you have the grid. Establish a view similar to one of the drawings (left) and plot the arrangement of objects on to tracing paper over the grids (right).

TASK 11
Plotting space 2

Draw the same group of objects set up in Task 9 from the same point of view, only this time placing them on a sheet of white paper. Try to judge their relationships in the light of the knowledge gained when they were on a grid.

TASK 12
Plotting space 3

Sit in a different position, viewing the objects from the side. Or carefully turn the board on which they are placed around to offer a different view. Do a drawing and compare the way this view produces different spatial relationships for the objects.

Some points to note
(**A**) A pencil set across the grid at 45 degrees (pointing to the corners of the square), when drawn from a low vantage point appears almost horizontal (**C**).
(**B**) Objects that are apart and not touching may appear much closer together when viewed from a low position.

©DIAGRAM

Outside and inside shapes

Remember that as well as the shapes of forms there are also the shapes of space. These are the areas in and around the objects. Studying these helps check the accuracy of your record of the object's features, and it directs your attention to seeing the negative values of shapes. On the object itself, you should also examine the shapes made by colors and tones.

Basic shape as pattern
One usual way to maintain an accurate record of an object is to see first its basic shape – then the shapes in and around the object. Try to see the view of the object as a flat pattern, which often creates very unfamiliar outlines to the object.

TASK 13
Shapes
First copy a photograph of an object in a magazine. Then place tracing paper over the photograph and, using a felt-tipped pen, fill in the spaces around the object. Cover your drawing with more tracing paper and fill in the same areas and compare the two shapes. Repeat the Task with new overlays, filling in the shapes of the object.

TASK 14
The shape of form
Objects change their shapes as you change the position from which you view them. This is because the edges are surfaces seen side on. You can explore the variety of shapes produced by an object by doing a series of studies of a chair or similar open-framed object.

Seeing shapes

One very useful way of checking your ability to see shapes accurately is to place the object in front of a grid, then carefully record the irregular shapes of the outline against the regular shapes of the grid.

TASK 15

Testing shapes

1. Copy the grid on page 10 onto tracing paper.

2. Stand the book open at page 10 and place a standing object in front of it.

3. Carefully copy the shapes of the object set against the grid onto your tracing paper grid.

TASK 16

The shape of light

A very simple method of converting a picture to its basic elements is to draw lines along the edges of all the dark areas, then to fill these in to form blocks of tone. A good exercise or practice is to place tracing paper over photographs and shade in the colored areas or tonal areas. Although this produces flat patterned solutions, it is still useful as a means of seeing the basic elements of a subject.

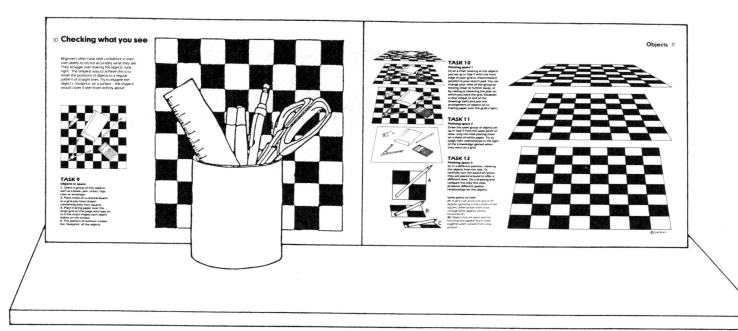

©DIAGRAM

The appearance of an object is very often the result of the direction and strength of the light source. Simple direct light produces very dark shadows with sharp edges. Numerous light sources produce soft edges and reflected light areas in the dark parts. As the shadows are the result of the forms, understanding the source of the light is one way to help describe the solid qualities of an object.

Remember when drawing a complex group of objects to keep the directions of the light sources constant. A frequent mistake of beginners is to draw each object as if independently lit. A simple method of avoiding this is to squint with half-closed eyes at your subject. This blurs the tones and simplifies the overall pattern of light and shadows.

TASK 17
Box
Do a series of shadow studies from changing light sources. Use any small available box such as a matchbox square-sided packet, or tin box. Light the subject with a small desk lamp which can be moved to a variety of positions. Record each shadow carefully.

TASK 18
Egg
Place an egg on a sheet of white paper in natural light. Do a pencil study with soft pencils, paying special attention to the reflected source of light on the underside of the egg.

Light sources
Right, a simple open box illustrates the changing effects of different light sources. These shadows are caused by light falling from the front, back, sides and above.

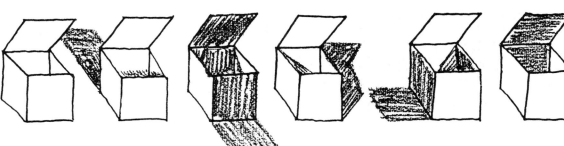

Regular solids
The individual facets of an object can capture in their dark areas light reflected from surrounding surfaces. This light has been bounced from nearby planes on to the object and produces a thinning of the dark areas. These are very useful in helping to describe the volume of an object as the darker areas between the highlights and reflected lights push the form forward.

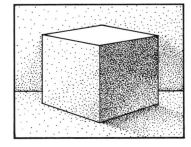
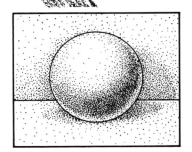
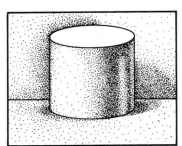
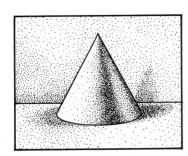

TASK 19
Reflected light
Working with soft pencils or chalks on cartridge paper, copy these regular solids (right) on to squares 3 in (7.6cm) square. Then imagining the light falling from a different source from the illustration above it, build up the tones on these regular solids. Work back into the dark areas with white chalk or an eraser to produce reflected light.

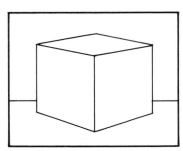

Ball and bowl

Below, this drawing uses shadows and highlights to describe a ball in a shallow bowl. The basic information of three concentric circles can be described in a variety of ways.

TASK 20

Interpretation

Make three separate drawings on cartridge paper, each one to show three circles with similar spacing to those shown below right. Using a soft pencil or chalks, build up the tones on each to describe the three different solids drawn, right.

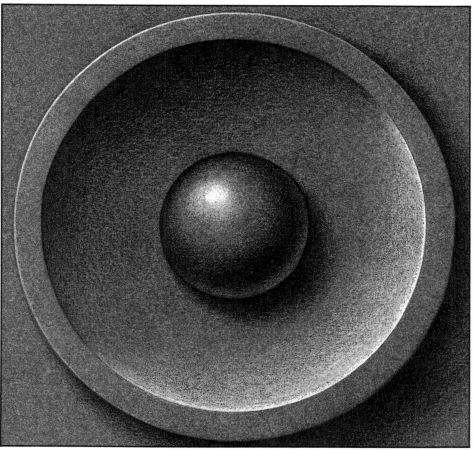

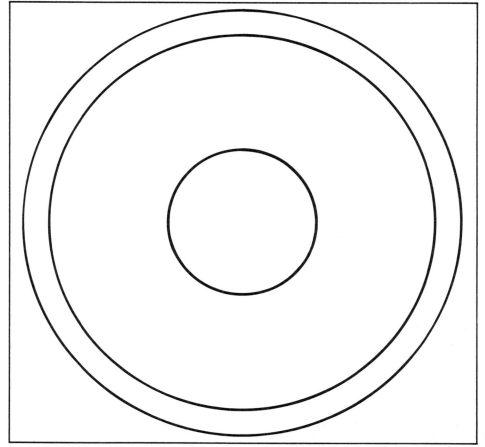

©DIAGRAM

The object you draw is capable of many interpretations. Unlike a circle, which is a line circumnavigating a center point and is always constant, each drawing is a record of a particular study. The quality of the drawing is the result of your cultural origins, your experience and your point of view. The type of tool and surface you work with also influences the results. A pen study is not like a brush study.

Artistic intentions
Below, this drawing of a crane was drawn to present an accurate description of the working parts.

Variety
A chair has a simple function — to support a seated figure, but designers offer an enormous range of shapes and decorations. The examples, right, are collected from different historic and cultural sources.

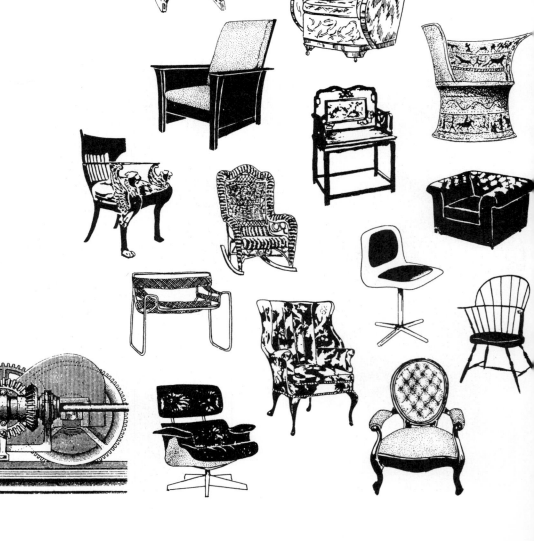

Emotional study
Below, this drawing is a fantasy sketch using a beer can as the source of inspiration.

Subjective study
Below, this drawing by Philip, aged 21, explores the effects of cross-line drawing and uses the can only as a reference for supplying shapes and tones.

Objective study
Right, this drawing in pencil by Lee, aged 17, is an accurate description of the reflections and colors of the object.

©DIAGRAM

TASK 21
Collecting themes
Make a collection taken from books and magazines of studies of the same object. Try to maintain an interest in one particular object so that you can build a file of examples such as shoes, knives, glasses, and collect examples from every period and culture.

TASK 22
Familiarity
Draw a familiar object from an unusual angle. Try turning it into a tall building or a space station. Impose on the subject an element of fantasy.

TASK 23
Subjective study
Choose a drawing tool unfamiliar to you, such as a technical pen, or a brush and redraw one of your earlier studies. Give more attention to the style of drawing than to the examination of the surfaces of the object.

TASK 24
Objective study
Do a very careful pencil drawing of an object. Make it a very small one, such as a key or watch, and try to draw the maximum detail. Record the surface details and all the tiny individual features to make the drawing as detailed and truthful a study as possible. Do your drawing the same size as the object.

Accurate observation
The previous 12 pages were directing your attention to looking and seeing — learning to record as carefully as possible the qualities of the objects you study. One key element of a drawing is the amount of concentrated thought you give to examining what you see. Drawing is a thought with a line round it.

TASK 25
Judging proportions
Stand this book open on the table so that the back half supports the upright front cover. Sit opposite, facing the cover straight on. Draw the cover as accurately as you can, making the base approximately 5 in (12.7cm) long. When the drawing is complete, draw a fine diagonal line through two opposite corners. This diagonal line should be the same as one on the book, so if you place the lower left corner of your drawing on the lower left corner of the book cover, the diagonal line should extend and meet the upper right hand corner of the book. This is to check that your judgement of the proportions of your drawing matches the proportions of the book.

TASK 26
Testing accuracy
Place five coins in a row, each touching its neighbors. Do a drawing as accurately as possible of the plan of this row, trying to draw the coins actual size. Do not trace the coins, judge their size by eye. When your drawing is complete, place the coins on your drawing to judge the accuracy of the overall length of the row.

TASK 27
Unusual views
This drawing of a spoon in a glass of water by Henrietta, aged 15 years, is an excellent study. Many objects offer the opportunity of an exciting drawing, if you first think about how best to view them. Select a comb, cup, hat, keys, or kitchen implement, and draw it from an unusual viewpoint.

TASK 28
Memory drawing
Five drawings by Jane, aged 11, of fruit and vegetables, drawn from memory. Try to draw the following objects from memory:
1. Your own or friend's bicycle.
2. Your bedside lamp.
3. Your winter shoes.
4. The hat of a friend.
When you have completed the drawing, obtain the real object and make a second study and compare the two drawings.

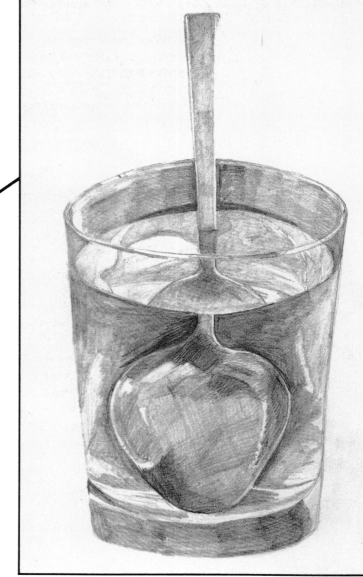

UNDERSTANDING WHAT YOU SEE

Most beginners are inhibited by the results of their work. 'It just doesn't look like the object' is their response to their early attempts. In this chapter there are forty-one Tasks set to explain how you record what you see by understanding the situation of an object in relation to your drawing surface.

Each of your studies is an invitation to whoever observes your work to step into the same space as that surrounding the objects you have drawn. Your primary task in learning to draw is to be able to describe the three-dimensional world using only two dimensions.

● The first two pages, 20 and 21, describe the solid world of each object — the space they fill.
● Pages, 22 to 25, help you consider the area around each object — the space objects stand in and how their surfaces appear in relation to your view.
● Pages 26 to 31, are essential to an understanding of how the appearance of an object is very often the result of our viewpoint. Where we stand when we observe the object influences what we see of it.

● The subject of perspective has always been a fearsome one for beginners, yet its secrets are easily revealed if you rely upon observations and not what you think an object should look like. Draw what you can see and check, not what you imagine.
● Pages 32 to 37, describe how to think of an object as having fundamental features that you can use to your advantage when studying it: its form; its symmetry; its irregularity; its surface qualities; and its inner qualities of hardness or softness.
● The review page, 38, returns to that most common fault of beginners — the failure to maintain accurate powers of observation. You will find guidelines on how to avoid some of the main pitfalls that prevent you getting satisfaction from your drawing.

The space objects fill

All objects fill space, even thin objects like envelopes or tickets. Remembering the volume of an object helps you record its three-dimensional properties. Try to think of the object packed up in a box, whose sides touch exactly the top and bottom, sides and front and back of the object. This container is the extent of the object's three dimensions and, although it may not appear in your drawing, the viewer must not be left in doubt as to where it would appear on the drawing.

Tracking surfaces
Outline line drawings do not offer clues to the three dimensions as clearly as ones drawn with shadows and textures. It is often very revealing to imagine tracks made by a snail traveling across the surface in a straight line.

TASK 30
Tracking
Begin with lines that travel over the surface cutting the shapes clearly into halves or quarters (a and b). Then draw tracking lines from a variety of directions (c). Apply this on an overlay of tracing paper to the drawing below, and to photographs of objects in magazines.

Height, width and depth
Objects viewed from the front appear to have only height and width, but objects seen with three adjacent sides, have height, width and depth. Your drawing must always make this clear.

A Height
B Width
C Depth

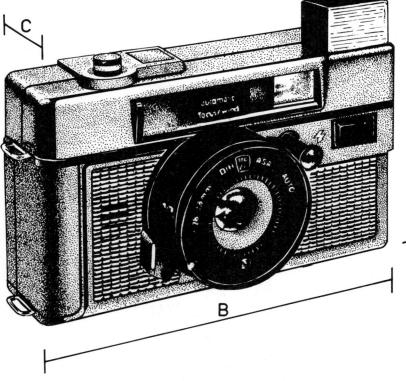

TASK 29
Three dimensions
Select any simple object viewed with three sides and do a very accurate pencil study, taking care to record the proportions of its three dimensions carefully.

Viewing all round
When drawing it is useful to keep in mind the plan and elevations of the object. How each would look if the object was looked at from directly above or from a side position.

TASK 31
All-round views
The drawings of a boot (below), show the top, side, front and back. We have all the information to describe a boot, but presented individually from each side. Do an invented drawing showing the boot from three sides – a three-dimensional view. It will help you if you draw a box (a sort of shoe box) into which the boot fits on each view. Then draw the box in three dimensions and construct the boot within the space.

TASK 32
Elevation
Draw this unfamiliar musical instrument from a view seen from the side, then from above, then from one end.

Outline and form
The outline drawing of a kettle does not describe the form very clearly. The lines can only use overlap to indicate position. By adding shadows the solidness of the kettle becomes clearer.

TASK 33
Form
Do an outline drawing of a domestic object, then shine a strong light from a single source on-to the drawing and redraw, adding the shadows on your drawing. Redraw with a new light source.

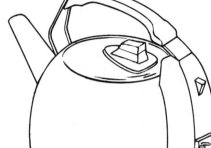

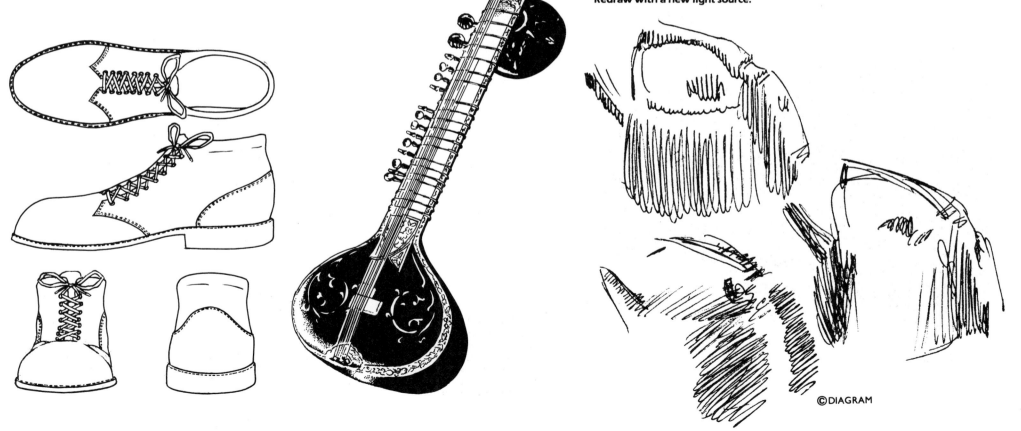

©DIAGRAM

Objects not only occupy space (their volume), they also stand in space in relationship to one another and their surroundings. They leave a 'footprint' on the surface they occupy. Drawing this spatial arrangement is often very difficult for a beginner. Placing the objects in space requires you to think around the object to its full three-dimensional form, and its nearest neighbors.

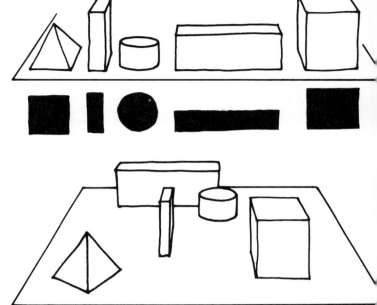

TASK 34

Chair

The feet of a chair are in a constant relationship to one another. They usually occupy four corners of a square. The placing of the four legs firmly on the ground can prove very difficult for beginners. It helps if you simplify the relationships to vertical and horizontal points (the dotted lines on this drawing). To test your ability to understand the 'footprint' of a chair, place it on a white sheet or clean, smooth, light-colored surface and do a drawing of the four legs. Move the chair to other positions and redraw the legs. Each time link the feet with connecting lines on your drawings. Notice how, although the legs never get closer to one another, their relationship in your drawing varies.

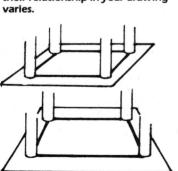

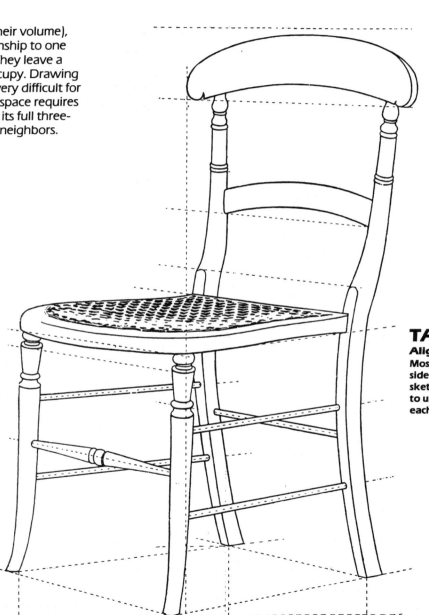

TASK 35

Alignment

Most objects are not seen in flat side view. The position in this sketch of five regular solids is simple to understand. The front edge of each touches a common front line.

The positions of the groups in the second sketch is not so easily established. Can you indicate on a tracing overlay where you think each stands on the base drawing below.

Thinking space
Below, this drawing of part of an art-school painting studio illustrates the problem of placing objects in space. Here are four easels, each with three legs, and each at a different angle to the picture and to each other.

TASK 36
Thinking space
Draw three chairs placed at different angles to one another. Plot the feet positions very carefully.

TASK 37
Floor guides
The position of the objects in this drawing by Vincent Van Gogh are more easily understood because of the texture of the carpet. Draw objects that are standing on a tiled or striped floor. If this is not available, place a group of small objects on a checkered cloth on a table and do a series of studies from a variety of different positions.

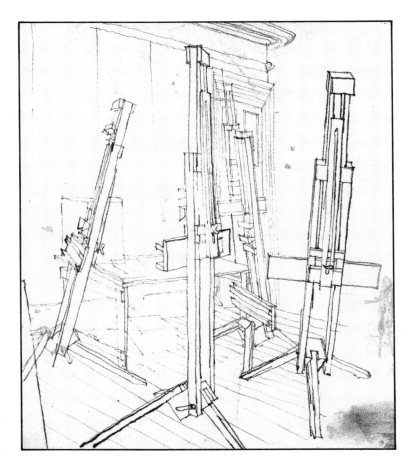

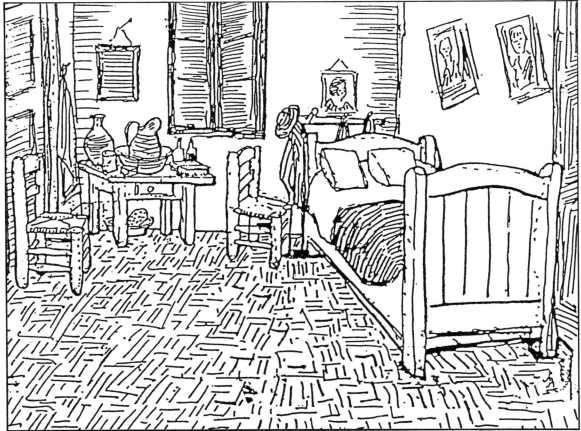

©DIAGRAM

Not only are objects seldom seen flat on to your position when studying them, but their surfaces are also turned away or toward you. Very few objects have vertical sides and a horizontal top surface. Most have irregular facets set at angles to one another. These surfaces give clues as to their direction if you look carefully at the lighting on the surface texture, or at the point where the edges occur. Remember that edges are usually surfaces seen from the side.

TASK 38
Surface clues
Draw an object with a strong textural surface.

TASK 39
Overlap
Draw an object with strong overlapping qualities, such as a cabbage, a discarded coat, or a crumpled bed.

Four ways to understand surface angles.
1. The overlap at the edges.
2. The overlap of other objects.
3. The surface textures.
4. The lighting effects.

Three studies of fruit
Bottom left, the pear offers only clues at the top and in the shadows.
The apple offers clues at the top and in the reflections of light and color.
The orange offers clues at the top and on the texture of its surface.

Right and below right, these two drawings viewed from either end of the row are understandable by the overlap of the surfaces one in front of the other.

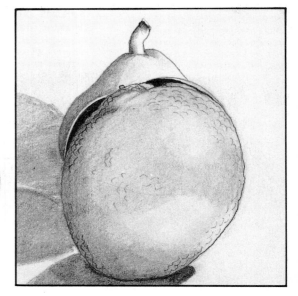

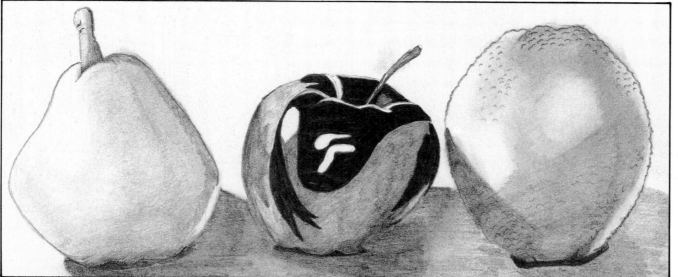

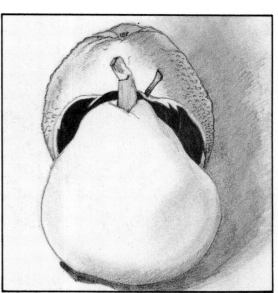

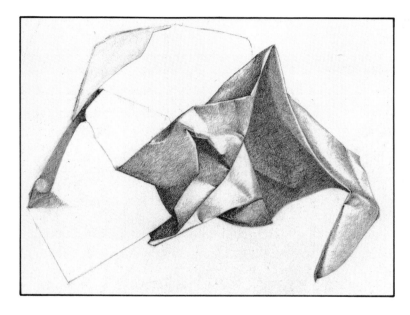

Surface patterns
Left, this drawing is of a crumpled wrapping paper. The artist records its form by the shading and the overlap of areas. The drawing below is of the same paper, in the same position, but only the stripes are drawn. Studying objects requires you to record the lighting, overlapping and surface characteristics.

TASK 40
Surface patterns
Draw a striped blanket, a jacket with strong patterns, and a patterned tablecloth.

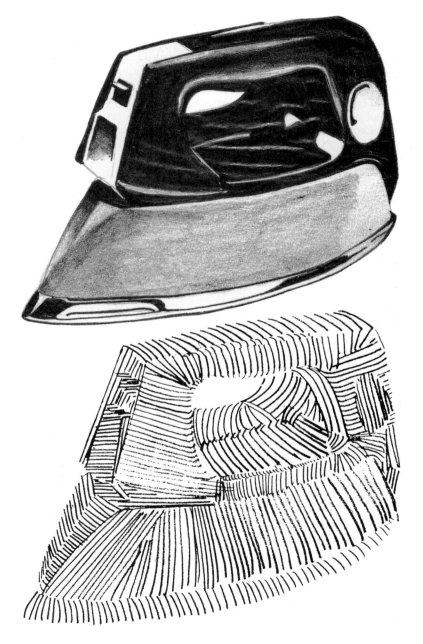

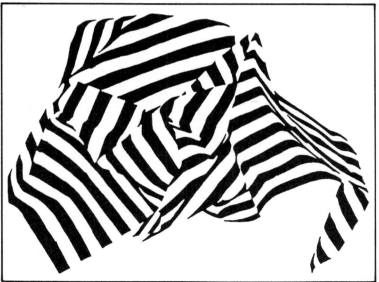

Surface directions
Top right, the very complex angles of the surfaces of this iron are described by carefully observing the lighting and the overlapping along the edges. One way to achieve this description of form is to think of directional lines that would travel all over the object. The drawing below attempts this solution. Even if you do not draw these directional patterns, it helps to think constantly of them when describing the form.

TASK 41
Directional lines
Place tracing paper over the drawing of the camera on page 20 and draw a pattern of directional lines following the surface planes.

The subject of perspective usually causes some anxiety in beginners. They feel they will lose themselves in the mysteries of geometry, mathematics and recessional space, which all seem to combine in a web of lines. This is quite unnecessary. Perspective is simply a method of checking what you see. Understanding how space appears from a single point of view helps you confirm your discoveries when you examine reality.

Three viewing positions
Below, center and right, standing, you see on to the top of a table. Sitting low on the ground, you see only the side view, and if viewed from below the base of the legs, you see the underside.

Simple principles
There are some simple facts to remember:
1. If you view objects straight on, horizontals are drawn straight across your vision.
2. If you move your position to view the object at an angle, then horizontal lines recede into the picture to meet in 'vanishing points.'
3. These distant groupings always occur level with your head, at a line running horizontally across your view – your eye level.
4. Wherever you stand, you always see the tops of objects placed below your eye level, and the underside of objects that are above your eye level.
5. Verticals are drawn straight up and down in all cases except when you stand close to objects and look up or down at them.
6. The closer you are to an object, the more you see of its top surfaces.
Remember, when your drawing does not 'look right,' try a simple test: extend into the picture the parallel edges of objects and these should meet at a common vanishing point.

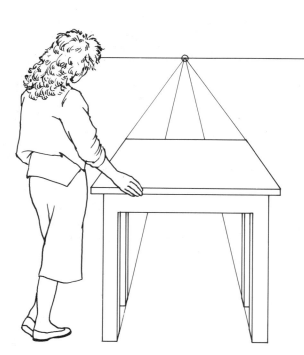

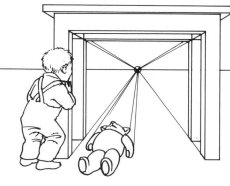

TASK 42

Position of an object
Sit on a chair and do three drawings of a small object, such as a vase, box or cooking utensil. First, look down on it (place it on the floor), then look at it from the side (place it on a table), finally, look up at it (place it on a high shelf).

Shelves
A good test of your understanding of the changing shapes of an object is to draw an object with a series of levels, like a cupboard. You will notice the following changes to the surfaces:
1. The lower shelves reveal a full view of their surfaces and objects on them.
2. The middle shelves show only their front edges and the objects are overlapping.
3. The upper shelves show only their undersides and obscure the objects on them.

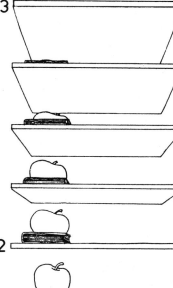

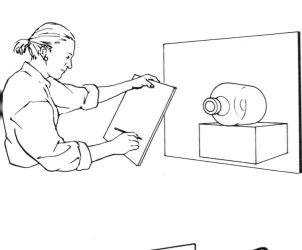

The picture plane
All images are seen and drawn as if projected on to a flat surface between you and the object. This is the picture plane. This imaginary surface flattens the object as if it were on a glass plate. The object seen closest to the picture plane is recorded larger than that seen in the distance. This is because the image of the object is a projected form from its origins in your eye.

Right, top surface objects show more of their top surface the closer they are to your position. Note the gap between the two boxes (**a**) on the foreground tables, and the overlap of the boxes on the distant tables (**b**).

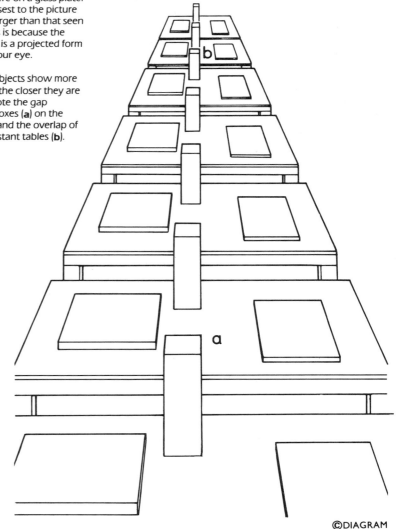

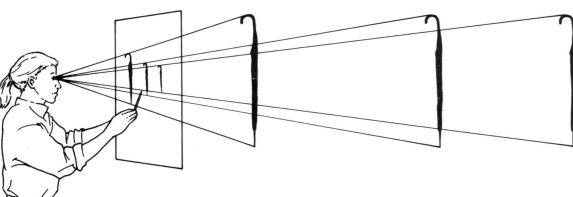

TASK 43
Position of the viewer
Place an object halfway up a staircase. Draw it from a position at the bottom of the staircase. Draw it from a position at the top of the staircase. Compare the two drawings.

TASK 44
Reducing scale
Place this book on a table and, sitting 2 ft (60cm) away, do a careful drawing of the table top and the book. Then move your position to a point 10ft (3m) away and repeat the drawing. Note that although your eye level has not changed, you will see less of the top surface of the book and table in the second drawing.

TASK 45
Surface views
Sit comfortably in a chair and do a drawing of a stepladder. Place this book on the lowest step and include it in the drawing. Then place the book on the middle step and include it, then place it on the top step and include it. Note the changing shape of the book in your drawings.

©DIAGRAM

The edges of an object that is not seen parallel or front view recede to two vanishing points, one at either side of the object. The distance they are from one another and the object is the consequence of how close you sit to the subject, and at how much of an angle its surfaces are turned away from you.

Parallel perspective
This drawing of a cupboard is made according to the idea of reality instead of how it actually is. All the front parallel edges should converge to a common vanishing point. This drawing records the idea of parallel edges and not the observed facts. Always draw carefully what you see and not what you think.

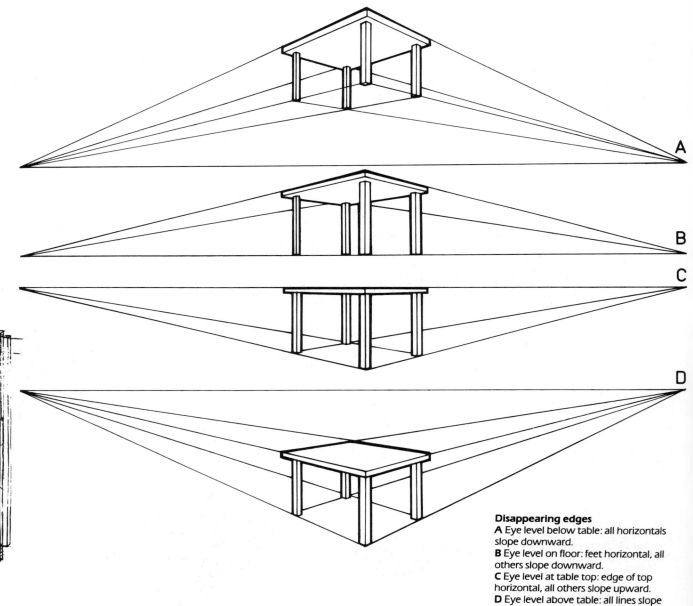

Disappearing edges
A Eye level below table: all horizontals slope downward.
B Eye level on floor: feet horizontal, all others slope downward.
C Eye level at table top: edge of top horizontal, all others slope upward.
D Eye level above table: all lines slope upward.

TASK 46
Cupboard door
To discover how top and bottom edges change with your view of the surfaces, do a series of drawings of a door, opening it in stages from a position where you can see its front, to one where you see the back. Keep your position constant and notice the changing angles of the top and bottom.

TASK 47
Recessional edges
Stand this book on the edge of the table with its spine pointing toward you. Do a drawing from very close to it, with your eye level at the table edge, and notice how both top edges appear to slope away from you.

TASK 48
Recessional surfaces
Judging recessional surfaces by placing this book in any position on a checkerboard. View the board from the same angle as the drawing below and, on a tracing overlay, plot the edges of the book against the squares. Repeat, moving the book to other positions.

TASK 49
Angles of recession
To test your ability to judge recessional angles, do a drawing of a checkerboard viewed from one corner. Then fold a strip of paper into an angled wing, matching the angle of your drawing (diagram, bottom right). Now view the checkerboard through the center 'V' and compare the angles of recession.

Horizontal recession
Right, this drawing of a checkerboard viewed from one corner clearly shows that the distant lines are more horizontal than those in the foreground. Compare the shapes of the nearest (**A**) and furthest (**B**) squares.

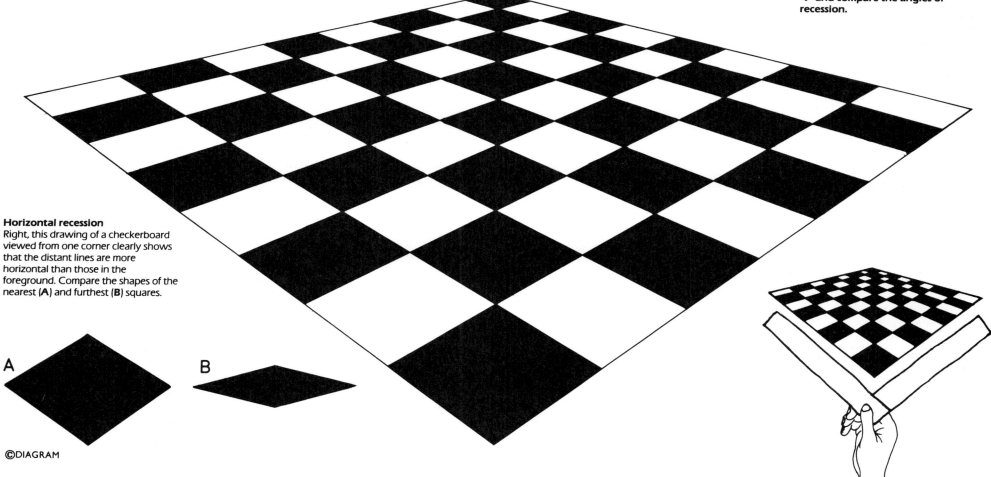

A

B

©DIAGRAM

Drawing objects with circular surfaces often causes a beginner problems. Remember that all circles fit exactly into squares, with the center of each of four sides touching four points on a circle. This very important feature is the key to constructing circles seen in oblique angles.

Surface areas of horizontal circles
Only circles seen directly from on top are circular. Others retain their common width but change their depth, depending on your point of view. To help you draw accurately an unfamiliar view of a circle, first construct a recessional square, cross the corners to establish the center points on the edges, then draw an oval that touches the center point on each side of the square.

TASK 50
Mastering circles
This group of circular objects clearly shows the construction lines. Do a drawing of a similar group of cups, saucers and plates, beginning each object by constructing the ovals around a central axis.

TASK 51
Seeing inside shapes
Draw a group of different shaped glasses. Place some in front of others so that you have the additional difficulty of seeing their shapes through the distortion of foreground glasses.

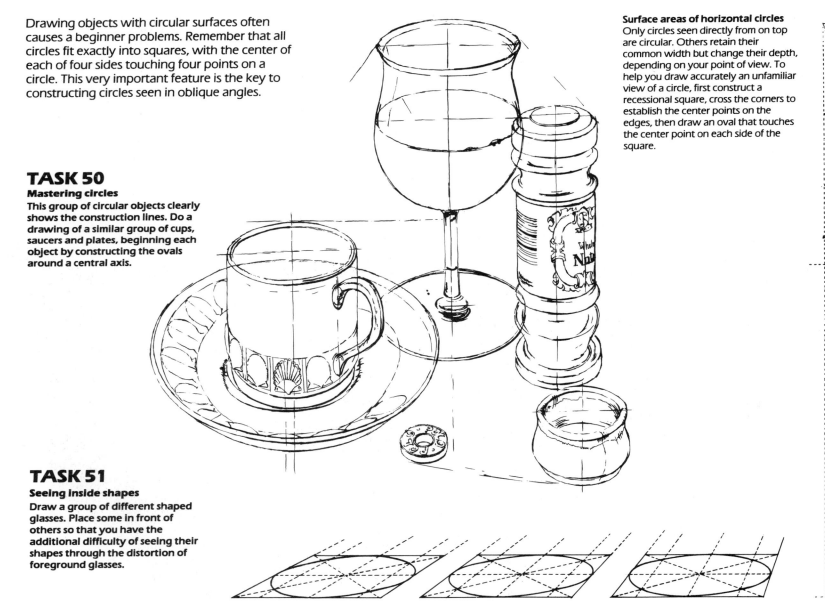
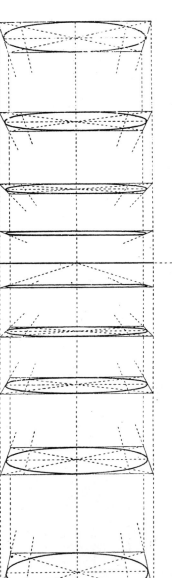

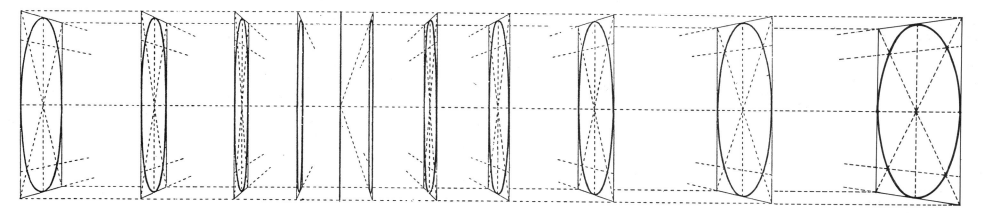

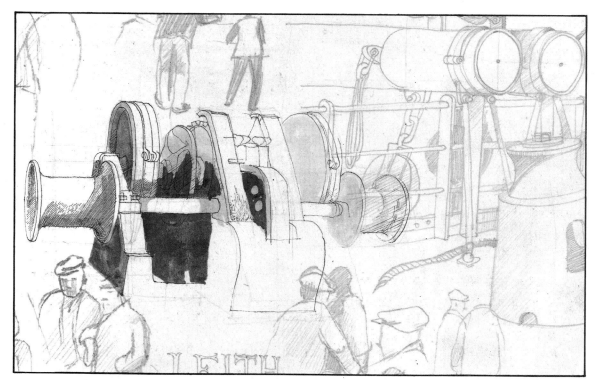

©DIAGRAM

Surface areas of vertical circles
Just as with horizontal circles, the distortion of circles is only in one direction. The height of a circle seen from the side is constant, only the width changes with your point of view.

TASK 52
Horizontal circles
Do a drawing on location of pipes, tubes, logs, machinery or objects that have different sized circular ends.

TASK 53
Extended circles
A very good exercise to help you master circular shapes is to draw a telephone cable or coil of wire. Although concentrating on the circular features, remember to keep in mind the overall shape of the object.

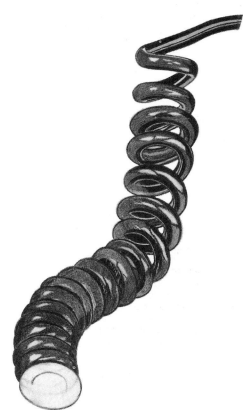

Many objects have an inner geometry. They are assemblies of parts that have a regular form. Their sides are mirror images or their top is like their bottom, or their front like their back. Many objects may not at first glance appear to have these features, but in constructing your drawing, it is useful to begin with center lines and build outward to balance shapes.

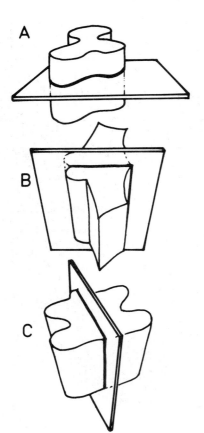

A

B

C

Three regular solids
A. Top is as bottom
B. Front is as back
C. One side is as the other
These three axes, which create similar halves, can be combined to form symmetrical objects.
D. Left is to right
E. Top is to bottom and left to right
F. Back is to front and top is to bottom and left is to right.

Simplified solids
Wherever possible, reduce the object you are studying to a group of basic shapes. Turn it into blocks of forms. This helps you judge the overall shapes and you can then work into your drawing the incidental smaller features.

TASK 54
Three-dimensional symmetry
Draw an object with three-way symmetry – a brick, a golf ball, a box of breakfast cereal.

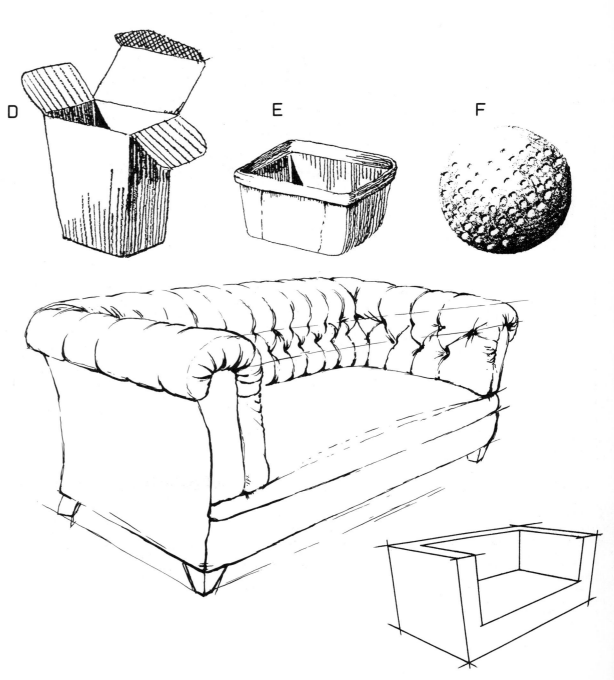

D

E

F

Different objects
At first glance, many objects can offer a very complex group of shapes. A spoon, a cane chair, spectacles, all seem very difficult to draw. But if seen as symmetrical objects, half the problem is solved as each object reflects the shapes of its other side.

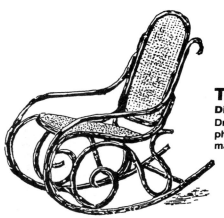

TASK 55
Discovering symmetry
Draw center lines on to photographs of objects in magazines and catalogs.

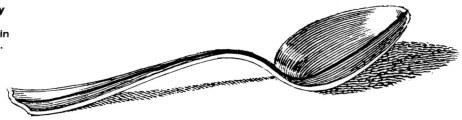

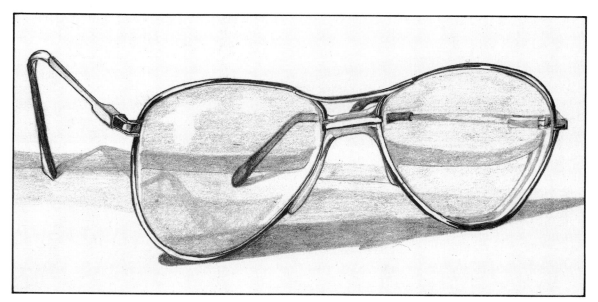

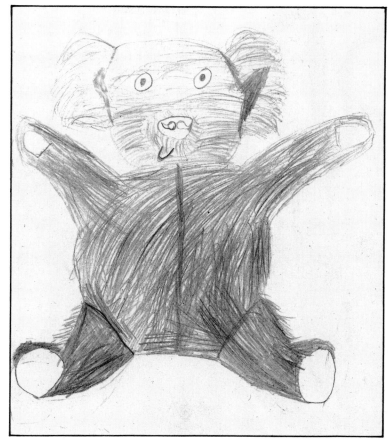

TASK 56

Simplifying objects
Do simple blocklike sketches of the main elements in the drawing of the camera on page 20. Notice how this block drawing helps you see the three-dimensional elements of the drawing. Apply this simplification to your own earlier studies.

TASK 57

Mastering symmetry
Draw a pair of spectacles, a man's hat, a fork. Begin with a center line and build up the two equal sides.

Unexpected symmetry
Right, this teddy bear drawn by Paul, aged 10, had a strong central line down its tummy. This helped Paul see that the left side is the same as the right on his toy.

© DIAGRAM

Because most objects we draw are familiar to us, we understand their actual qualities fairly easily from a simple drawing. It is only when we draw unfamiliar objects that we must pay careful attention to explaining whether the object protrudes into or recedes from the flat surface of the page. Think of the plan of an irregular object when you are struggling with its unique shape.

Natural objects
Right and below, the nuts and the shell may appear to be irregular but are, in fact, the result of natural geometry. As they grow they form their shapes. This development is often hinted at in the surface textures, so study carefully the small detail to be able to draw the object more accurately.

Irregular objects
The gloves and scissors are examples of objects with a real symmetry. Seen from the top they are easy to understand. Drawn from the side, they present difficulties.

Irregular objects
Right, these two drawings by Philip, aged 18, capture very beautifully the sense of old worn material. The care with which the detail has been observed gives us the feeling we would know the bag if ever we were to see it.

TASK 58
Infinitely variable objects
Draw a coat lying over the arm of a chair, or a cushion, or a discarded crumpled newspaper.

TASK 59
Natural objects
Do a series of studies of vegetables, fruit, shells or stones. Take special care to record their surface textures.

TASK 60
Irregular objects
Draw a pair of scissors, a pocket knife, a shoe, or any available object that is irregularly shaped.

TASK 61
Exploring irregular shapes
Collect examples of small objects, such as keys, and do drawings actual size.

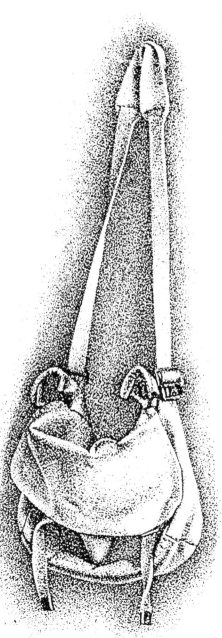

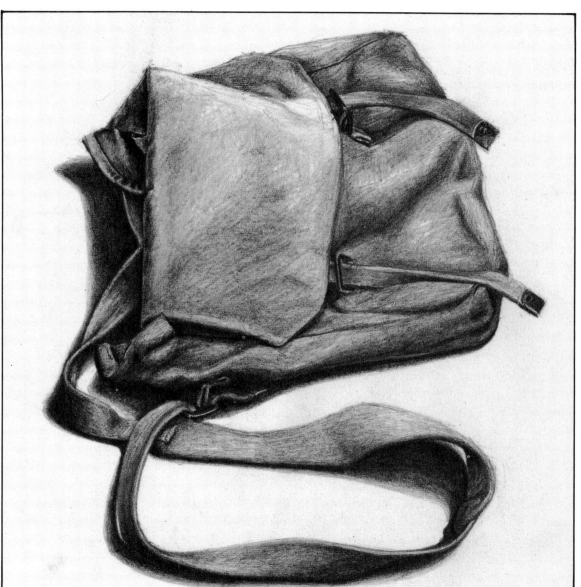

©DIAGRAM

The surface of an object is very often a good guide to its character — as hard as nails; as soft as silk; as stiff as a poker. Your drawing should capture these surface qualities and you should make a practice of collecting examples with strong textural qualities.

Textures
Below, a clear way to observe textures is to study colorless objects. A pencil drawing by Jane of a group of white objects: cup, egg, cloth, bread, soap.

Reflective surfaces
Below, a silver coffee pot drawn by Lee, aged 17. This modern replica has a very highly polished surface which Lee has successfully described by using a soft, sharp-pointed pencil.

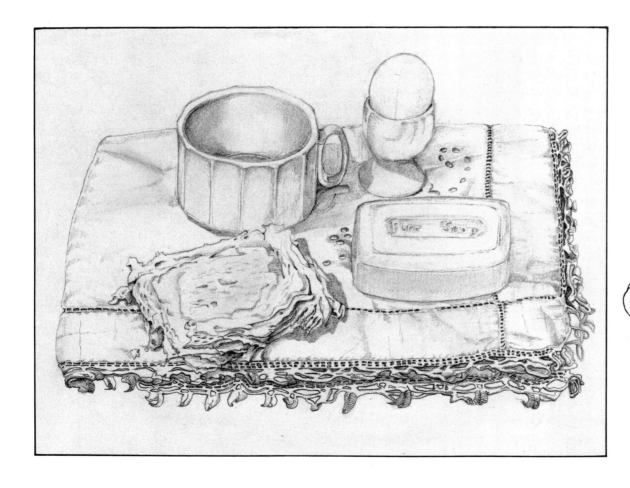

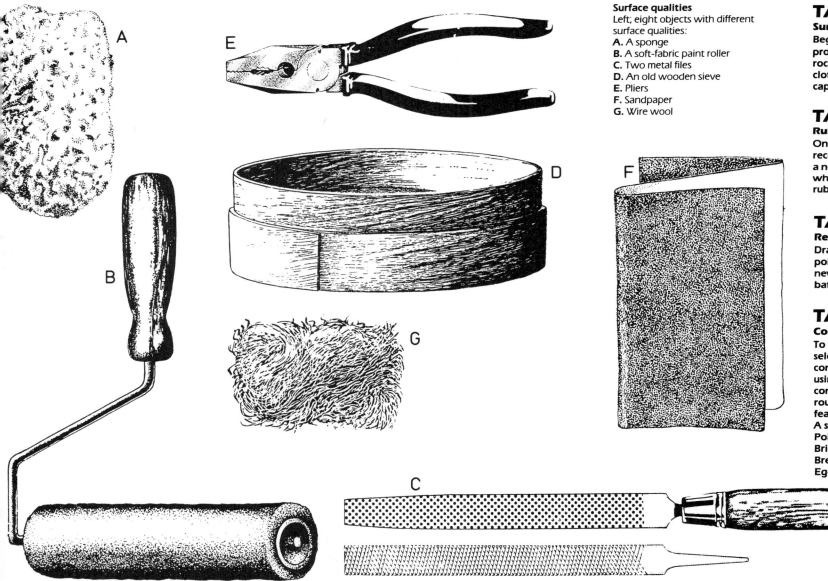

Surface qualities
Left; eight objects with different surface qualities:
A. A sponge
B. A soft-fabric paint roller
C. Two metal files
D. An old wooden sieve
E. Pliers
F. Sandpaper
G. Wire wool

TASK 62
Surfaces
Begin to collect examples of pronounced surface textures such as rocks, sea-worn wood, old sack-cloth or rusty iron. Do drawings to capture these qualities.

TASK 63
Rubbings
One very good method of recording surface texture is to keep a notebook of thin paper into which you add wax-crayon rubbings of interesting surfaces.

TASK 64
Reflective surfaces
Draw objects that have a very polished surface, such as new shoes, new kitchenware or garden tools, bathroom objects.

TASK 65
Comparing textures
To help you judge surface qualities, select two objects with strongly contrasting textures. Do a drawing using pencils in which you concentrate on capturing the rough, smooth, dull, reflective features. Possibilities are.
A sponge and soap
Polished floor and wooly rug
Brick and glass
Breakfast cereal and bowl
Egg and potato.

©DIAGRAM

Examine reality
The previous thirty-six Tasks were designed to set you studying what you saw and understood of your observation. Remember, always rely on what you see and not what you think is there. Examine reality very carefully and it will yield its secrets.

TASK 66
Reappraising your drawings
Check all your previous drawings for construction faults and if now you feel you could do better, redraw a previous exercise.

Three Tasks
Three Tasks set to test your powers of imagination. Imagine that the camera and the telephone on page 20 were standing side by side. Then try the following exercises. If you feel inclined, you can select other objects than those on page 20.

TASK 68
Common unusual view
Do a drawing in which you imagine that you are looking down on to the top of both objects.

TASK 69
Common light source
Invent a light source that is falling from above left. Then redraw the two objects with the shadows common to both.

TASK 67
Common space
Do a drawing in which both views in the original are adjusted to a common point of view.

Understanding circles
Right, a very good drawing by Henrietta, aged 15, in which the final overall impression is marred by a simple mistake. She failed to realize that the circles on the objects should all be consistent. The table is seen almost directly from the top but the bottle and glass are seen almost from the side.

Some common faults
1. Failing to draw ovals correctly. The circular parts of objects must all be consistent with one another.
2. Failing to observe simple recessional features of parallel lines.
3. Failing to place the objects correctly in space.
4. Failing to construct correctly a regular proportional object.
5. Failing to maintain a common light source.
6. Failing to relate objects to a common space.

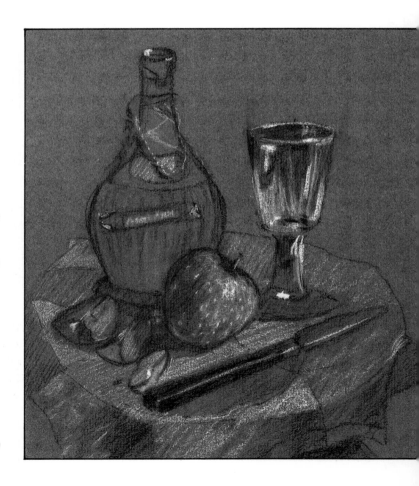

Although the most popular beginner's drawing implement is a pencil, very many more tools are available and they can be mastered. This chapter contains twenty-four Tasks to involve you in the opportunities of exploring the marks made by different tools.

Begin with the tools that you feel are most comfortable. Then, when the opportunity arises, explore the use of other tools with which you have had little experience.

Remember that whatever tool you use and however interesting the marks are on the page, it is more important to care for what you say than how you say it. Clever effects are impressive, but often of little real value.

- The first two pages, 40 and 41, contain twelve examples of the same subject recorded by a student using a variety of drawing tools. These clearly reveal the way marks influence the appearance of the drawing.
- Pages 42 to 45, are examples of marks made by the most popular drawing tool applications – the dry-medium pencils and chalks. These offer such a wide variety of effects and can be easily corrected. Therefore, they are by far the best choice when you begin your earlier drawings.
- Pages 46 and 47, describe the less familiar wet-medium tools. Beginners usually find it harder to work with pens and brushes as they can be difficult to handle confidently at first. Their marks are hard to remove or modify.

- Pages 48 and 49 describe some of the types of drawing surfaces available and how these influence your choice of drawing tool.
- The final page of the chapter sets you the Task of reviewing your understanding of the quality of marks made by different tools.

Three factors combine to create the quality of the drawing. The tool, the paper surface and your experience and confidence. These pages illustrate the effects of different tools and the confidence with which different students handle them. Some are more suitable than others for your Tasks, and some you will feel more comfortable with than others. In addition to your most favorite drawing tool, try on occasions to explore the effects of using less familiar tools.

Changing tools
Below and opposite, twelve examples of the same subject study drawn with a variety of tools.

1. Soft pencil on rough paper.
2. Hard pencil on tracing paper.
3. Charcoal on rough paper.
4. Crayons on white paper.
5. Crayons on dark paper.
6. Pen on smooth paper.
7. Ball-point pen on smooth paper.
8. Brush on smooth paper.
9. Felt-tipped pen on smooth paper.
10. Technical pen on smooth paper.
11. Mixed media.
12. Colored pencils on dark paper.

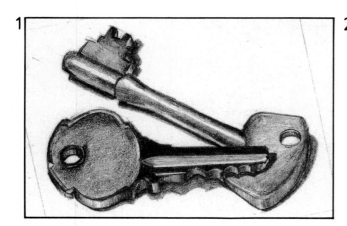

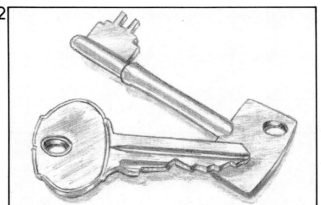

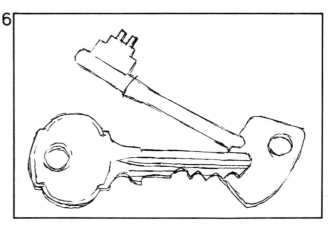

TASK 70
Judging originals
Visit the local art galleries and try to see examples of artists' original drawings. Take care to examine the method by which they were drawn.

TASK 71
Judging reproductions
Collect examples of drawings in magazines and books and make a note on them of how you think they were produced. Be careful, as many are reproduced smaller than when originally drawn.

TASK 72
Paper surfaces
Collect whenever possible examples of different types of paper. Keeping a portfolio of types of paper means you can always experiment on new surfaces with familiar or unfamiliar tools.

TASK 73
Exploring techniques
Redraw one of your earlier drawings or copy a photograph from a magazine using a tool you have never used before. It might be a technical pen or wax and waterolor.

7
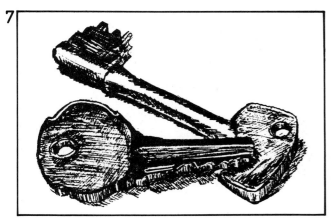

8
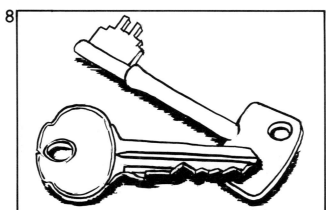

9
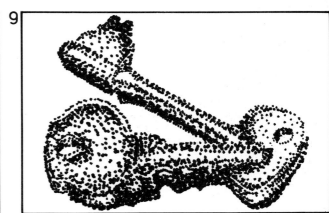

©DIAGRAM

10
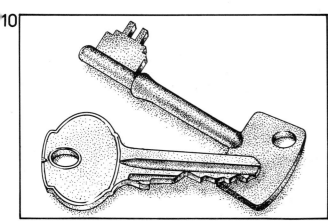

11
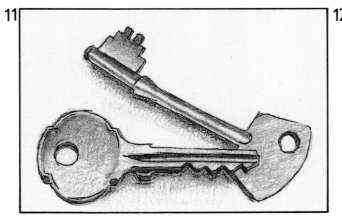

12
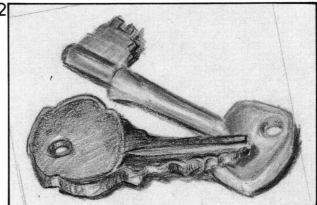

Pencils, chalks, charcoal and crayons are all dry-medium tools. They are convenient to use as they offer a wide range of tones and can produce fine or broad marks, depending on the condition of the point. In addition, they can more easily be corrected so a beginner feels less inhibited using a pencil than a pen.

Pencils
There are a variety of pencil- like objects. Wooden-bodied are the most common, but fine leads mounted in a holder are also handy as the lead can be retracted when not in use and they do not require sharpening. All pencils are graded for 'hardness' — this is the quality of the graphite 'lead' base. Softer leads make darker marks, harder leads make lighter marks. Softer leads wear down quickly so you must resharpen the point frequently. Harder leads are only suitable on strong fine-grained paper. The softer the lead, the more likely the drawing is to smudge.

TASK 74
Pencils
Collect together all your pencils, check you have sharpened the right end of each. You should have left untouched the end with the grade mark. Any pencil that constantly produces broken leads, should be discarded.

TASK 75
Sharpeners and erasers
Keep one small drawer of your work cabinet for sharpeners and erasers. You should have: scalpel holder and blades, sharp penknife, oil stone, sandpaper and a variety of erasers.

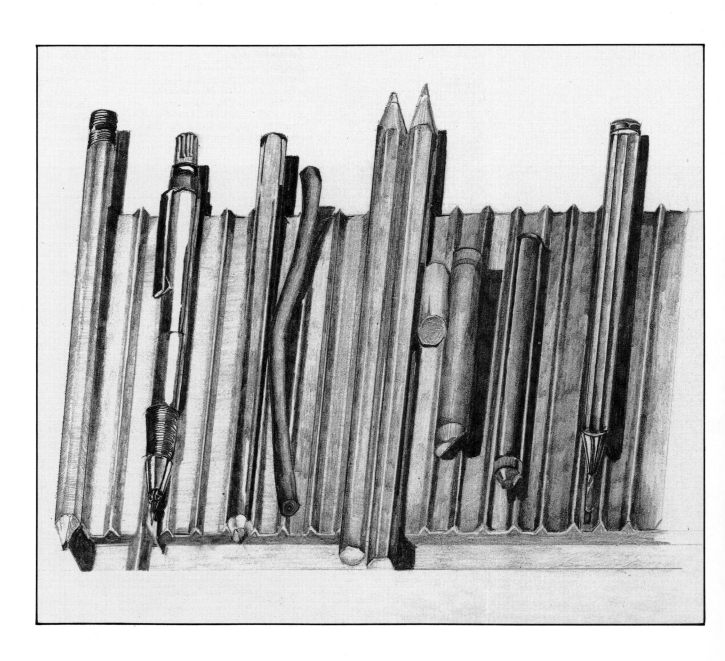

9H 8H 7H 6H 5H 4H 3H 2H H HB B 2B 3B 4B 5B 6B 7B 8B

Grades of pencil
9H is the hardest in common use and 8B the softest.

Tone and shades
Pencils are excellent at creating an even tone. By gently rubbing the pencil regularly across the surface you can achieve a tone that does not show the individual marks.

TASK 76
Gradation
Draw a series of 1 in (2.5cm) squares. Begin one side as a solid black line and gently shade the white area to produce a regular, even-graded tone from black to white.

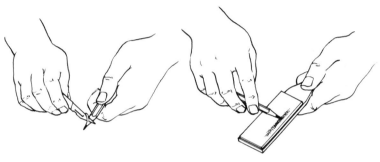

TASK 77
Tones
Practice building up areas of tone that have an allover even quality. Select one of the values on this drawing (left), and shade an area of equal value. Then fold over the edge of your paper to place the tonal patch you have drawn on the folded edge so that you can visually match it to the examples here.

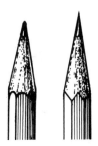

Tones and shades
Right, detail (actual size) of an excellent study by Henrietta, aged 15, which shows the advantage of working in pencil. She has used fine soft lines to plot the subject. Then she strengthened the edges she felt confident with and, finally, used the side of the pencil to shade large areas.

Sharpening pencils
Always sharpen your pencils with a tool that cuts away the wood in a direction away from your work, usually over a dust bin. Remove carefully thin slices of wood, working gradually to expose an even round point. Complete the sharpening of the point by gently filing it down on a strip of sandpaper. Store your sandpaper or sandpaper blocks in an old envelope.

Points
Hard pencils should have long sharp points. Soft pencils should have short exposed points.

©DIAGRAM

Working with charcoal sticks, crayons and chalks, offers you the opportunity to build up areas of tone as well as vary the line thickness qualities. The major advantage of these tools is the wide variety of tones and marks available, some created by blurring with your finger, or highlighting with an eraser. The most common practice is to use a tone-colored paper, either light brown or blue. You must always work on surfaces that have a texture rough enough for the fine particle of charcoal, wax or chalk to stick to.

Types of tool
There are two main types of drawing stick – those based on water adhesive and those with an oil base. Beginners should use the water-based sticks as these allow you to make changes to the marks.

Water-based
1. Pastel sticks with protective paper cover.
2. Pastel pencils.
3. Chalks.
4. Graphite stick.
5. Charcoal.

Oil-based
6. Wax crayons.
7. Colored pencils.

Working the tones
Below, when using water-based chalks, it is possible to alter the tonal effects by techniques other than drawing lines:
A. Broad areas of tone can be produced by using the side of the chalk.
B. Fingers can be used to smudge edges.
C. Lighter areas can be obtained by removing the chalk with a putty eraser. If you do a charcoal drawing, you can use a ball of soft bread to the same effect.
D. Highlights can be achieved with lighter colored chalks working over the dark areas.
E. Areas can be softened with an eraser.

TASK 78
Storage
Collect all your chalks, crayons, charcoal sticks in one small drawer or box. Take care to keep them wrapped in tissue paper and separate from one another.

TASK 79
Exploring techniques
Redraw one of your earlier studies using an unfamiliar tool. Possibly colored chalks on brown paper.

TASK 80
Artists' drawings
Obtain books with examples of reproductions of chalk and charcoal by famous artists. Remember that most illustrations in books are not the size of the original drawing. Examine how they achieved the tonal effects and how they used chalks and charcoal. Copy one of their drawings.

1 2 3 4 5 6 7

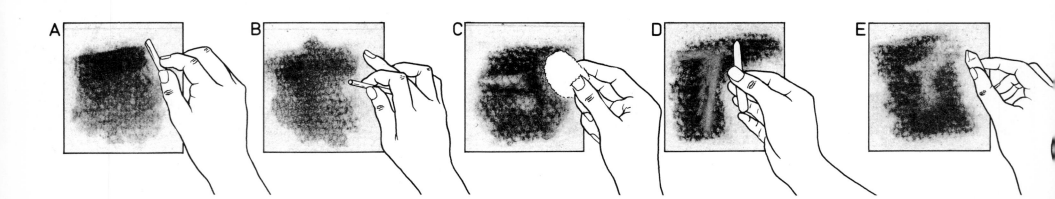

A B C D E

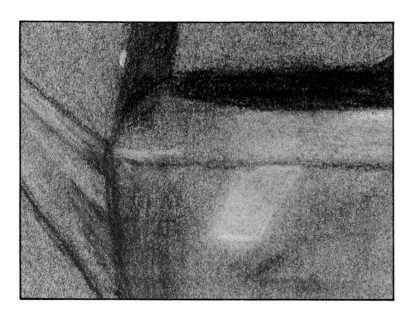

Light to dark
Right, this chalk drawing by Rebecca, aged 8 years, makes excellent use of the opportunity of working back into the drawing with light chalks. The original was on colored paper and was drawn with a variety of colored chalks. This drawing is greatly reduced but a section, actual size (left), shows how the chalks hold to the surface.

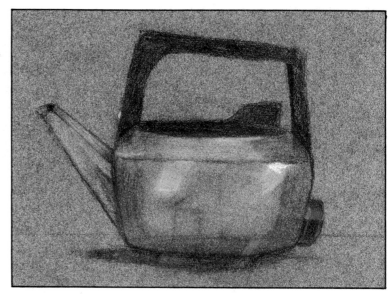

Working
Left, very often it is advisable to rest your hand on a small sheet of paper laid over your drawing. This prevents the texture, moisture and temperature of your hand from smudging your drawing.

Fixing
Right, all dry-medium drawings should be fixed with a spray of artists fixative. Do not use pressurized canisters as these are harmful to your health and damage the earth's atmosphere.

TASK 81
Fixing
Check that all your drawings have been fixed, and are stored so that no two drawings face and touch one another.

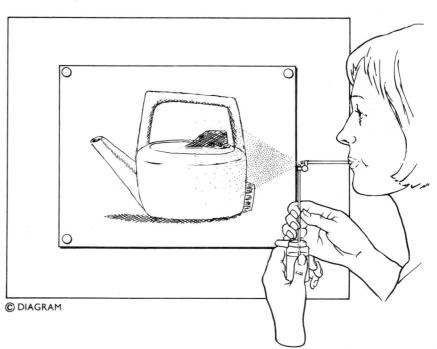

© DIAGRAM

Wet-medium tools

Using tools that produce a mark made by ink has a major disadvantage for beginners. Once you have made the mark on the paper with brush or pen, you cannot easily lighten or remove it. Inks are usually water-based which means they are absorbed into the paper.

The advantages of wet-medium tools are that if you work confidently, they can produce a wide range of beautiful marks. Creating tone requires either a slow build-up of fine lines and dots, or the application of layers of ink washed on by brush.

Mixed media
Below, this drawing of a statue uses a mixture of pen and ink and finger smudging. Note the fuzzy lines (lower right), due to drawing on a wet surface. The shadow on the leg is a smudge of the knee.

TASK 83
Mixed media
Do a drawing on strong smooth paper and while working with a pen and ink, smudge the lines to produce tones. This may spoil your drawing but if you work lightly with water-based inks, you can produce attractive results.

The most popular wet-marker tools are:
1. Brush.
2. Writing pen.
3. Technical pen.
4. Ball-point pen.
5. Felt-tipped pen.
6. Broad-tipped felt pen.

TASK 82
Technical pen
Redraw one of your earlier drawings using a technical pen. Work on strong tracing paper over your drawing.

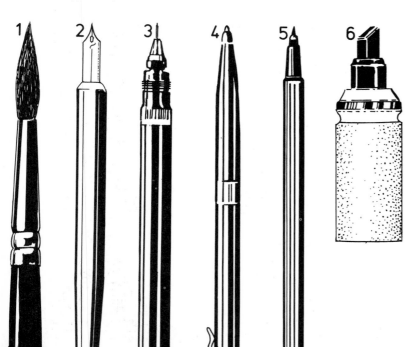

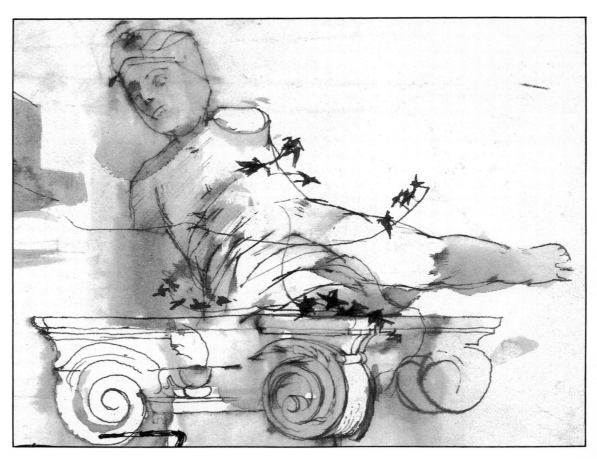

Tonal values

Left, achieving an even range of tone is a matter of practice. You can create the illusion of darkening areas by:
1. Varying the thickness of lines.
2. Varying the space between equal-thickness lines.
3. Criss-crossing lines.
4. Building up areas of tiny dots.

Building up tones

Pens produce a line and not a tone. To achieve an area of tone, the pen must be used to produce multiple marks either as lines or dots.

Building a line drawing

Below, four drawings using pens. These examples have been considerably reduced. First begin with a fine pencil study of the construction of the object.
Each subsequent drawing was produced on tracing paper placed over the base construction. Working this way enables you to carry out a free and confident study without revealing the earlier construction.

TASK 84
Tonal values

Build up a series of tube-like objects, practicing achieving an even range of tone. First try by lines, then dots, then cross-hatching.

TASK 85
Building a drawing

Do a very accurate pencil construction of an object. Then place tracing paper over your construction and do a free rendering in pen.

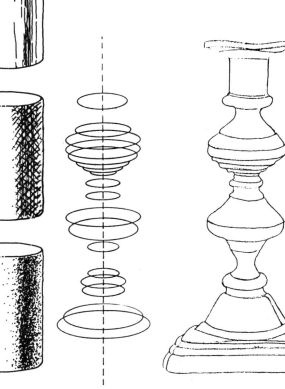

When beginning to learn to draw, use the basic tools and surfaces available in the local art supply store. It is always possible to do interesting drawings with any tool on any surface, but when beginning some tools can prove difficult to handle on some surfaces. Avoid working with fine pens on rough-textured paper, or with brushes on thin paper.

Surface qualities
It is not possible to include in this book surfaces other than the one on to which the text is printed. Nevertheless, you can see the consequences of working on different surfaces by details from four drawings reproduced actual size.

A. Plastic
Drawing reproduced actual size done with a technical pen and ink on plastic material.

B. Newsprint
Felt-tipped pen on newsprint, actual size.

C. Cartridge
Pencil on a rough-surfaced cartridge, actual size.

D. Tracing paper
Hard pencil on a good-quality tracing paper.

Factors
You should consider three qualities of the material you draw on. 1. The texture of the surface, rough or smooth. 2. The strength of the paper (usually its thickness). 3. The paper's color.

TASK 86
Unfamiliar surfaces

Do a drawing on brown craft paper or rough-textured paper, using a range of tools, pencils, pens, brushes – to experience the different effects of the marks on the surface.

TASK 87
Collecting examples

Store examples of the different types of paper you discover in a portfolio so that you have as wide a range as possible of papers to experiment on.

TASK 88
Plastic surfaces

Purchase a small piece of technical drawing plastic-surfaced material and do a very detailed pen drawing, having first planned the subject study on paper.

A

B

C

D

Paper types
There are a wide variety of papers but normally you are limited to those available in the local art stores. Below is a list in order of cost and quality.

Newsprint paper	Very cheap, poor-quality paper, usually cream colored. Not suitable for pen and ink or brush drawing.
Tracing paper	Very useful to explore with as you can place a second sheet over your first drawing and redraw, preserving the successful parts and changing other parts.
Stationery paper	The type used in typewriters. Very cheap, usually a standard size, good for pen drawings. Usually not rough enough for pencil or chalks.
Cartridge papers	These are the traditional artist's cream-colored papers. Good-quality papers have a fine-textured surface for pencil and chalk drawing.
Ingres paper	Expensive, good quality. Often in pale colors, not suitable for pen drawing.
Water-color papers	Often handmade, expensive, have a strong thick quality. Not suitable for pen work unless with a fine surface grain.
Bristol board or card	Fine-surfaced white paper mounted on board or smooth surface card. Very good for pen work, but not suitable for pencil drawing.
Plastic	Used by professional illustrators for pen work. Not suitable for pencil. Gray opaque surface enables you to work over a previous drawing.

Judging reproduction
Right, this drawing by Philip was done on a sheet of stationery paper with a soft black pencil. The reproduction here is a reduction from the actual size. The detail, above, is actual size. The quality of a reproduction is affected by the scale of the illustration to the original.

TASK 89
Sketch pads
Begin to carry a sketch pad with you on your outings and always have a pencil ready for drawing objects of interest.

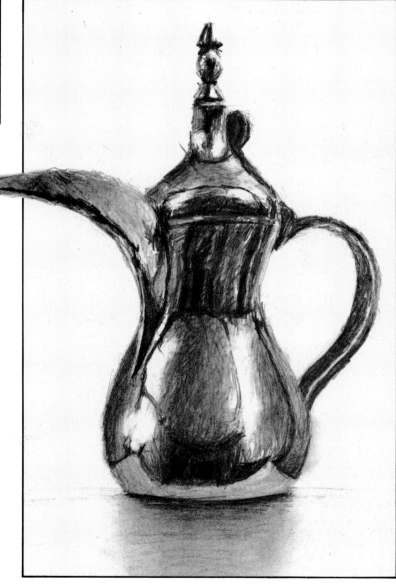

Graphic qualities
This chapter has introduced you to qualities of drawing that are the consequence of marks made by different tools on various surfaces. These graphic qualities can provide additional aspects to a drawing's merits.

TASK 90
Work area
Find a corner of your home where you can set up still-life subjects and study them without risk of them being moved. This is particularly important if you want to do the same subject study in a variety of techniques.

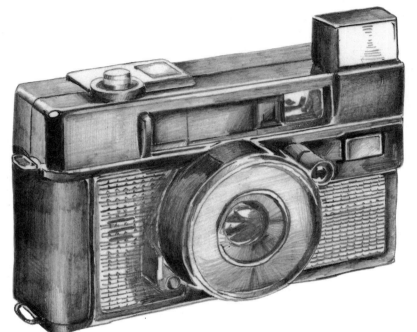

TASK 91
Conversion techniques
Redraw any of your earlier Tasks or any drawing in this book, using a technique other than the original. This is a pencil study of the illustration on page 20. Can you identify the tool used to do the original drawing?

TASK 92
Understanding techniques
Can you identify the drawing method of the following illustrations:
The apples on page 7
The shell on page 34
The gloves on page 34

TASK 93
Soft pencil study
The scissors by Lee, aged 17, were drawn with a pencil on stationery paper. He first constructed the study very carefully with a light plotting of shapes. He then built up the tones using a soft pencil. Do a study of a reflective object using a soft, sharp-pointed pencil.

CONSIDERING DESIGN CHAPTER 4

Having fun with your drawing skills is really the purpose of this chapter – seeing the drawing as independent of the subject and then looking at the end result as the product of how you approached the problems of selection and composition.

This chapter is concerned with how you enjoy and exploit the graphic qualities of your work, with Tasks to help you explore the style of your drawings.

There are four main factors to consider before you begin a study: the choice of objects – some rare, some common, some familiar and some strange; the grouping – how subjects stand beside each other; the lighting; and, finally, the position of objects within the frame of your picture.

The more subjects you study, the more tools you explore and the more adventures you begin, so your confidence increases and you become capable of producing drawings that reveal a unique view of the world and produce results that will impress your friends.

- The first four pages, 52 to 55, are about the way beginners hesitate when selecting objects to draw. What do you draw? How do you select a subject? The world has millions of objects and how do you find one that you can use in your drawings?
- The subject of pages 56 and 57 is one most enjoyed by beginners – how to make their drawings look real. Adding detail is looked at as well as building a technique that produces admiration in the observer.
- Pages 58 to 61, are on how to view the subject from within the edges of your frame – composing the subject.

- Pages 62 and 63 have examples of drawings that go beyond reality. Drawings where the artists have had a particular reason for their point of view, and this has influenced the results.
- Finally, page 64 has an example of a single study to illustrate the charm and beauty that can be obtained from working in pencil and looking very carefully at the subject.

What do you draw? How do you make the subject interesting? These two questions often inhibit a beginner. Every object offers you a challenge: how to make it an interesting subject to study. A simple shape such as a pencil can be turned into a fascinating drawing if you view it imaginatively. Most homes contain hundreds of small objects of a wide variety of shapes, materials and conditions. Some are new, some are old, some common, some unfamiliar.

The unusual
Left, these joke replica plastic flies offered the opportunity to do a quick ball-point pen sketch.

Found objects
A pen, brush and ink study of an old broken bird cage. Even if incomplete, sketches made on location often contain items of interest due to their uniqueness.

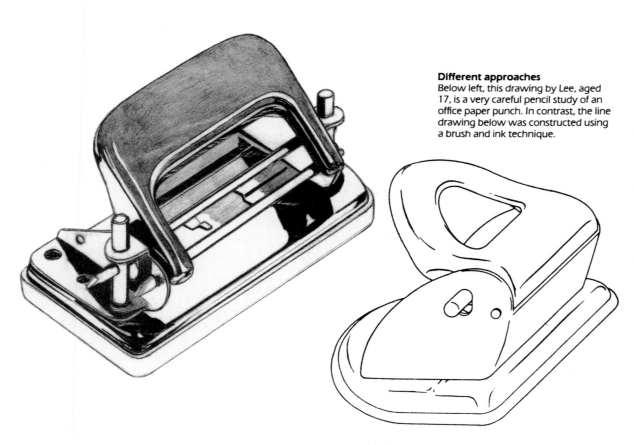

Different approaches
Below left, this drawing by Lee, aged 17, is a very careful pencil study of an office paper punch. In contrast, the line drawing below was constructed using a brush and ink technique.

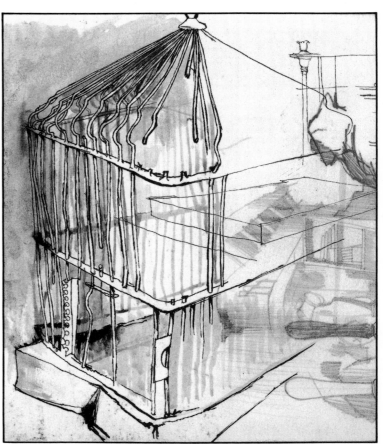

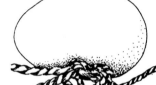

TASK 94
Subject studies
Keep a sketch book devoted to variants of one narrow subject study. For example:
Sea shells
Worn stones
Jewelry
Antique furniture
Ornaments
Ceramics
Any subject you find personally interesting.

Fish
Below, a very careful pen and ink drawing of a fish.

Unusual objects
Above, a plaster cast of a child's teeth — a ball-point pen study reproduced actual size.
Examine old magazines and books for photographs and drawings of unusual objects. Trade catalogs, mail order catalogs all offer a very wide range of subjects.

Compositional factors
When selecting and arranging objects, think of their comparative qualities, their shape, size, color, texture condition and use. Choose objects whose contrasts are:
round and square
smooth and rough
bright and dull
large and small
common and rare

Interesting objects
Below right, the interest in these old shoes rewards Henrietta, aged 14 years, with the good results she gets from a careful pencil study.

TASK 95
Exploring details
Looking closely at small objects can produce interesting studies. Do a drawing larger than the subject taking good care to study all the tiny details. Objects could be a tiny dead beetle, the inside of a watch, or an old worn small object.

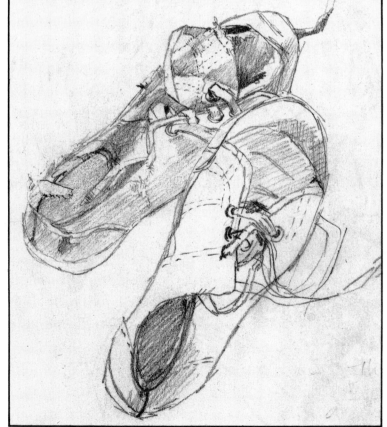

TASK 96
Common objects
Begin with this list of ideas and select one available in your home. Do a variety of studies from different points of view.
Hats
Shoes
Bottles
Vegetables
Fruit
Shells
Kitchen utensils

TASK 97
Unusual objects
Begin with this list of ideas and select one available in your home. Do a variety of studies from different points of view.
Broken toys
Discarded crumpled papers
Driftwood
Worn furniture
Old tools
Old weapons or musical instruments
Old shoes

©DIAGRAM

Your home may provide you with subjects to study, but going out on location, or collecting unusual objects, widens your source of ideas. Museums, antique shops, beaches, forests, scrap yards, all provide opportunities to discover subjects to study. Many famous artists had a private collection of odd objects that they could study for ideas. Rembrandt had a collection of skulls, armor, classical sculpture, plaster casts, furs, fabrics and jewelry, all of which he used as props in his paintings.

Museums
Left and below, a pencil study of a suit of armor and a pen study of a crab, both drawn in a museum.

TASK 98
Museums
Go to your local museum and sit in a corner away from the main avenues of the public. Do a very detailed study of some unusual object.

Exploration
Below, this pencil drawing of half a cabbage illustrates the opportunities available for finding interesting subjects among ordinary household objects.

TASK 99
Exploring the unfamiliar
Cut open a fruit or vegetable and do a very detailed drawing of the unusual shapes revealed.

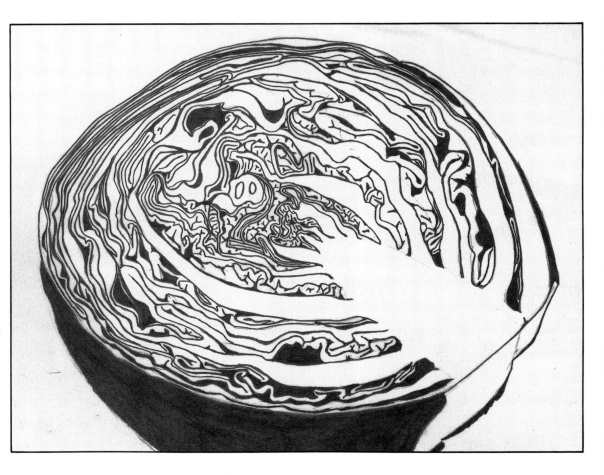

Outdoor objects
Left, a pen study of old railway signals and, right, a pen study of a 19th-century steam engine. Both illustrate the interest you can discover in outdoor objects.

TASK 100
Outdoor objects
Make a long-term study of some common object that has a large variety of forms – possibly city street lights, park benches or fire hydrants.

TASK 101
On-location studies
Keep a sketch book devoted to one narrow subject study made on location. For example:
Street furniture
Vehicles
Graves
Iron-work
Select a subject to which you have access – possibly boats, trains, cars, plants, trees, houses.

TASK 102
Sketch pad work
Collect small objects and commit them to memory in a small sketch pad. Elastic bands, wrapping paper, broken containers, keys, the contents of a small boy's pockets – all offer opportunities for a careful, actual-size pencil study.

Themes
A collection of studies of small architectural details observed in a 19th-century cemetery.

Drawing objects as carefully as possible so that you can record every tiny detail is not to copy reality but to enhance it by careful exaggeration. Most successful drawings are built up from carefully drawn understudies, usually made in pencil and very often finished with a sharp dark pencil or technical pen.

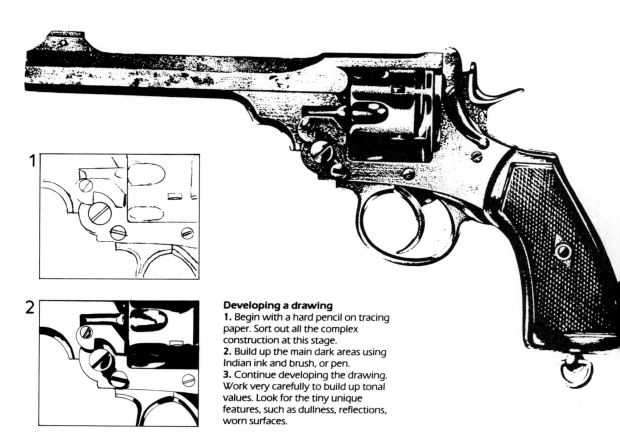

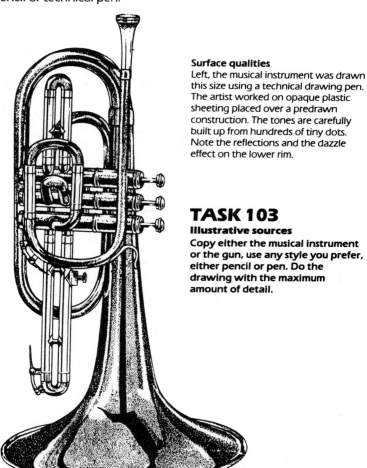

Surface qualities
Left, the musical instrument was drawn this size using a technical drawing pen. The artist worked on opaque plastic sheeting placed over a predrawn construction. The tones are carefully built up from hundreds of tiny dots. Note the reflections and the dazzle effect on the lower rim.

TASK 103

Illustrative sources
Copy either the musical instrument or the gun, use any style you prefer, either pencil or pen. Do the drawing with the maximum amount of detail.

Developing a drawing
1. Begin with a hard pencil on tracing paper. Sort out all the complex construction at this stage.
2. Build up the main dark areas using Indian ink and brush, or pen.
3. Continue developing the drawing. Work very carefully to build up tonal values. Look for the tiny unique features, such as dullness, reflections, worn surfaces.

TASK 104

Photographic sources
Do a very careful study of an object from a photograph in an industrial catalog, sports goods catalogs, musical instrument manufacturers catalog, or a source of good clear photographs.

Notice board
Successful drawing depends greatly on your powers of observation. Graham's pencil study of the objects collected on his notice board are all drawn actual size and reproduced here the same size.

TASK 105
Natural size
Collect a group of thin objects, such as tickets, notices, envelopes, keys, jewelry and pin them to a board. Do a very careful study of them to the same size as reality.

TASK 106
Surface detail
Look at the drawing of a hammer on page 9 and then draw a similar study of an object that has a variety of surface qualities – part dull, bright, rough, smooth, soft and hard. Try to describe all the surfaces as accurately as you can.

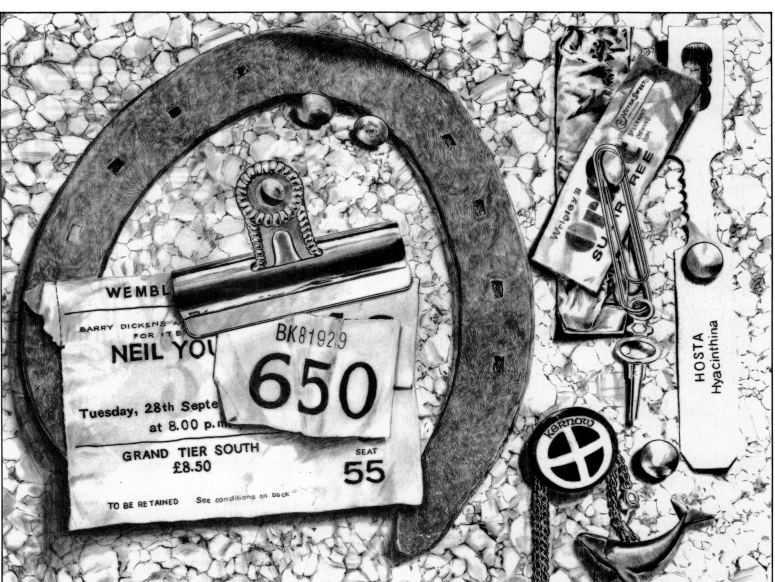

For still-life studies, two aspects greatly influence the drawing's possibilities: what you draw and then how you view it. The choice is often a very personal one and remember that anything can be interesting. First do a series of sketches of the arrangement of the objects. Do not settle for the first solution, explore other groupings and viewpoints.

Lighting
Right, when setting up a still-life try a variety of lighting arrangements. Even with a simple cup, the changing directions of lighting produce quite different effects on it and on our understanding of the subject.

TASK 108
Lighting
Select an object that you feel you can draw carefully. Next do a series of drawings each with a different light source.

Arrangements
A group of objects can be arranged in a variety of ways.
A. They can be displayed facing the picture plane – a series of overlapping, flat, front-facing objects.
B. They can be displayed receding into the picture area – usually lying down and pointing into the page.
C. They can be arranged in a more complex way with some set at odd angles to the picture.

TASK 107
Grouping
Do three studies of the same group of objects: first arranged flat upright, square to the picture; secondly, all laid down receding into the picture; then in a disorganized arrangement.

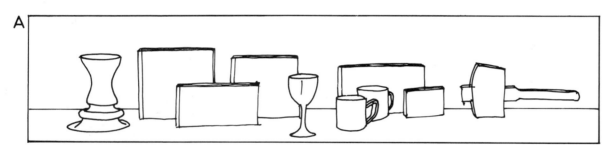

A

B

C

Composition

The possibilities for the positioning of a subject within a frame is the result of four factors:

1. Your position when you view the subject.
2. The subject's position in the frame.
3. The size of the subject in the frame.
4. The proportions of the frame.

Factors influencing the composition

A. Your position. When beginning a study choose a simple view if the objects are complex. Complicated views can be hard to draw.
B. The subject's position. Usually, your drawing should be within the central area of the paper, so that you can compose a framed view later.
C. The subject's size. Normally draw the subject with a minimum of 2 in (5cm) around it. It is usual to draw the subject smaller than actual size.
D. Frame proportions. Sketch pads, artist's paper sizes, commercial papers are usually rectangular and your drawing should be centered to enable you to apply a variety of formats to the rectangle.

A

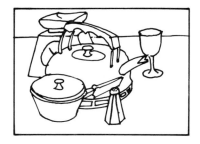

B
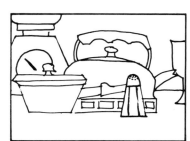

C
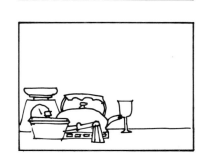

D

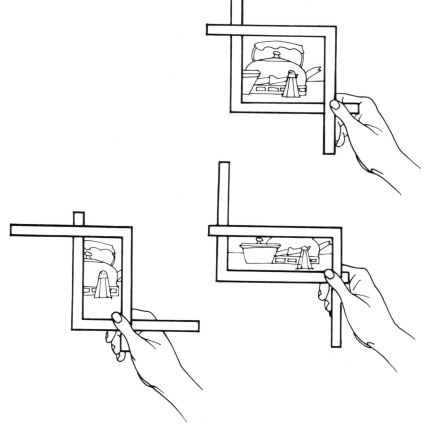

TASK 109
Composition
Do an analysis of the basic composition of still-life paintings in your local art gallery.

TASK 110
Framing
Make an adjustable pair of L-shaped frames so that you can sketch a variety of compositions within changing frame shapes.

©DIAGRAM

Your view of objects

Simple objects can be the source of interesting drawings if you consider the point of view you select when examining them. Never begin a study without first doing a few very quick sketches of the object from a variety of view-points. Begin with simple views and later, when you feel more confident, select unusual ones.

TASK 112
Positioning
The drawing of a book is made interesting by the view in which its open pages fan out and in the way it is lit. Do a similar drawing of this book by standing it open on the table.

Unusual view
Looking down on the subject can be interesting as it offers a visual interest to what could otherwise be a dull subject study.

TASK 113
Unusual view
Try viewing your composition looking down on the subject or selecting a corner of the grouping.

TASK 111
Viewing
Select two objects and stand them side-by-side on the table.
1. Do a front view of them, then a side view.
2. Do another view looking directly at them, then do a view from on top.

3. Do two studies from oblique angles, either from above and the side, or from close up with a distortion.

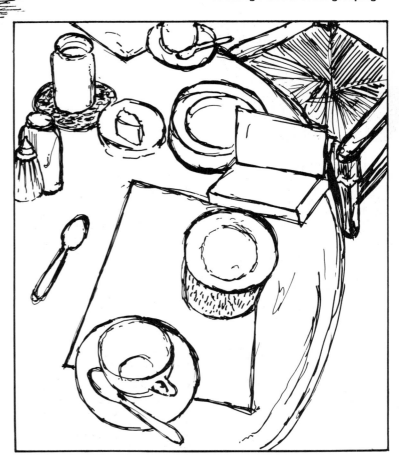

1

2

3

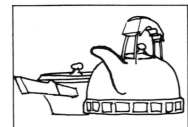

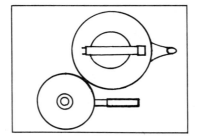

TASK 114
Drama
This is a simple paper stapler but the view creates a dramatic scene. Select an object such as a cooking implement, or carpentry or gardening tool and do a study which has a strong sense of drama.

TASK 115
Pattern
The simple silhouette of the chair is interesting because we seldom see the chair from this position. Do a drawing of a chair in your home viewing it from an unusual angle.

TASK 116
Subject
This drawing of a human skull is interesting for two reasons. The subject is strange, and the view is unusual. Try to obtain unusual objects which you draw from unusual angles.

Objects can be seen as representing ideas. They have an interpretation other than what they look like – they represent what we think of them. You may have personal views of an object which, if successfully described, add more to our understanding than straight recording of what you see. Your drawing can open our eyes to new ways of seeing reality.

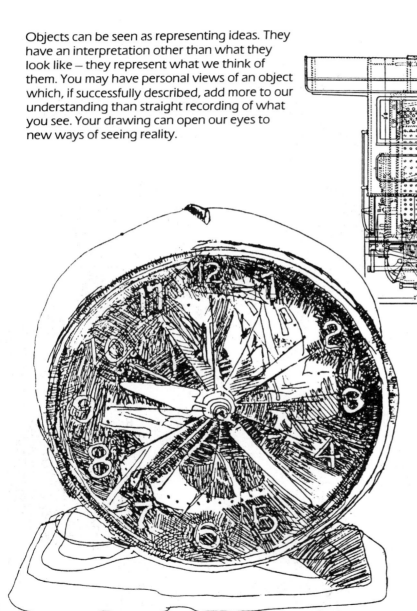

TASK 117
Ideas
The drawing of a clock is not a description of what it looks like, it is more: it is a drawing of the idea of time. Select an object that represents an idea and describe the thoughts through the drawing. Try perhaps a knife, a shell, or an old worn-out object.

TASK 118
Formalization
Two drawings of men's suspenders. The elastic irregular-shaped objects have been presented in a formal pattern in these drawings from a 19th-century catalog. Turn one of your subjects into a designed structure.

TASK 119
Information
Drawings of objects are often used to convey information. This transparent engine drawing shows all we may need to know about how the inside relates to the outside. Do a transparent-style drawing of your fridge, medicine cupboard, or larder.

TASK 120
Imagination
The drawing of a scallop has exaggerated its features. It has become a fantasy drawing. Select an object and find the most dramatic way of reinterpreting its forms.

TASK 121
Drawing style
This drawing by a 19th-century Chinese artist of a small rock relies upon the style of drawing for its interest. Do a study of a simple object but hold the drawing implement in the hand not normally used for drawing. Redraw the subject using your normal hand and compare the qualities of line.

TASK 122
Graphic possibilities
These drawings of the insides of fruit are experiments in interpreting the way in which the shapes can be transformed into exciting designs. Turn one of your earlier studies into a flat arrangement of shapes.

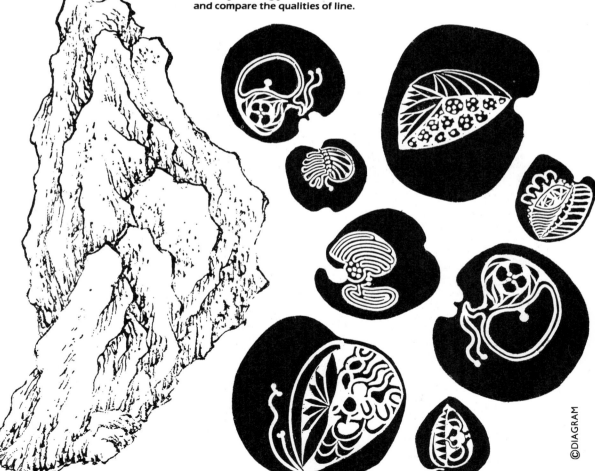

Develop skills

Drawing objects is a study from which you can learn a great deal before you begin the more exacting tasks of drawing people and places. Many artists have used the accessibility of objects as a convenient way to develop their skills and powers of observation.

TASK 123

Research

Visit art galleries, collect books on art, cut illustrations from newspapers and magazines. From wherever possible copy other artists' work.

TASK 124

Records

Check that all your drawings are marked with the date and your signature. You must constantly re-examine your work, but you must have an inner pride in your achievements to spur you on to more studies.

TASK 125

Pride

Select your very best study. Spend money on a professional service and have your drawing mounted and framed. Display it in your home.

TASK 126

Collecting

Begin a lifelong collection of one type of small object – possibly a type of ornament, candlesticks, ashtrays, salt cellars, horse brasses.

TASK 127

Study

Begin a lifelong study of your favorite object. Start by doing studies from books, become a specialist in the study of one small object.

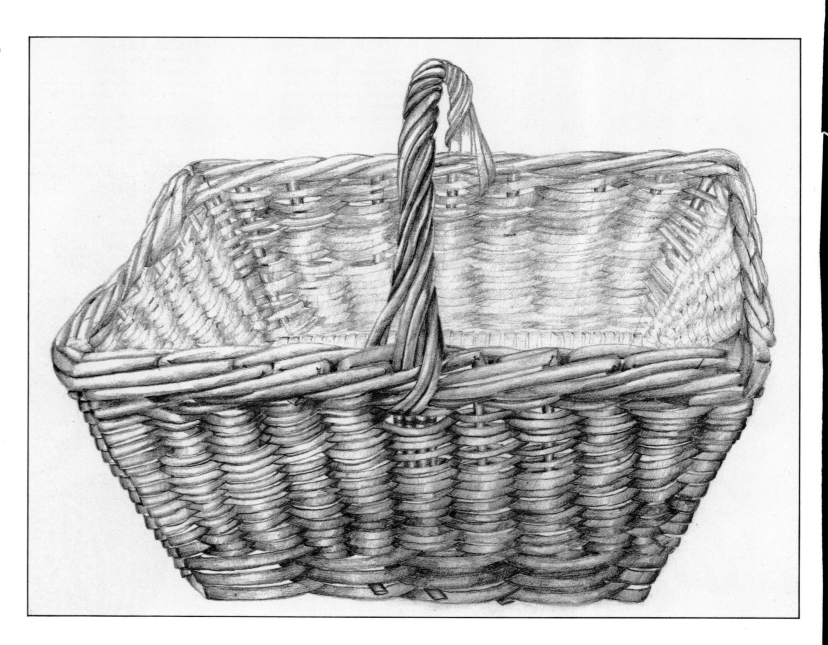